IMAGES
of America

AMBLER

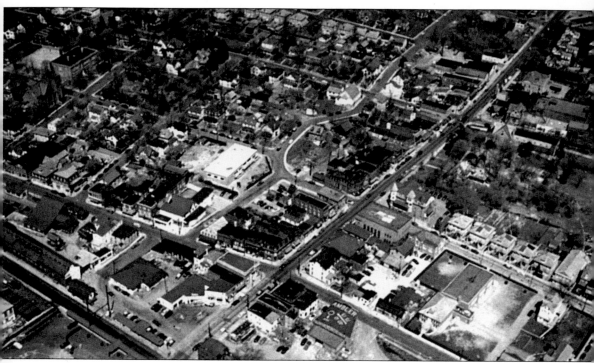

This aerial view of Ambler, taken by Herb Lanks, shows that apart from normal modernization, the borough has changed very little in the years since Richard V. Mattison had 400 houses built at the beginning of the 20th century to accommodate the executives, supervisors, middle managers, and blue-collar workers employed by the Keasbey & Mattison Company. (Collection of Ross Gordon Gerhart III, *c.* 1960.)

IMAGES
of America

AMBLER

Frank D. Quattrone

ARCADIA

First published 2004
Reprinted 2004

Published by Arcadia Publishing,
Charleston SC, Chicago IL, Portsmouth NH, San Francisco CA

Printed in Great Britain

Library of Congress Catalog Card Number: 2003112240

For all general information, contact Arcadia Publishing:
Telephone 843-853-2070
Fax 843-853-0044
E-mail sales@arcadiapublishing.com
For customer service and orders:
Toll-free 1-888-313-2665

Visit us on the Internet at www.arcadiapublishing.com

*To the many people whose love, support, and encouragement
over the course of several months allowed me to bring this book to fruition.*

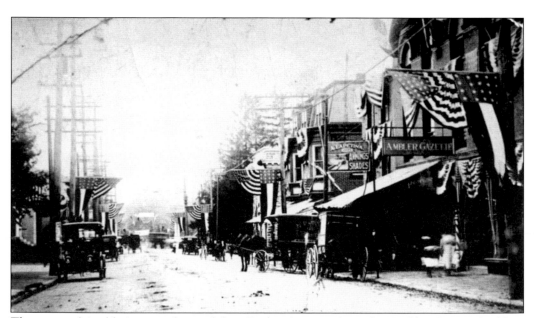

This view of Ambler's main thoroughfare, Butler Avenue, from the Ambler Gazette building looking west shows the peaceful collision of two centuries on what is probably Armistice Day 1918. Parked on either side of the avenue and facing the camera are several horse-drawn carts and carriages juxtaposed with the automobiles that would soon replace them. (Collection of Ross Gordon Gerhart III.)

CONTENTS

PREFACE

Ambler was inspired in part by Arcadia's wonderful Images of America series, which I have been reading for pleasure and consulting for years as sources for the town pieces, or history articles, I write for *Montgomery County Town & Country Living* magazine, edited by Bob Waite and Diana Cercone and published by William N. Waite.

It was also inspired by my own upbringing in an Italian American neighborhood in South Philadelphia, not far from the Italian Market, where I came to love and appreciate the largely unheralded contributions of immigrant working-class families much like those who helped build Ambler.

It was also inspired by four young ladies who love picture books and who may one day appreciate this modest attempt to capture a small slice of history. They are my four granddaughters: the golden-haired twins, big-hearted, sweet Samantha and adventuresome, spicy Jennifer, two and a half years old; and their older cousins, cuddle-bunny Allison, four and a half, and my beloved muse Melissa, all of eight and a half, who shares with me a passion for American history and reading in general, and whose repeated inquiries, "How is your book coming along, Grandpa?" propelled me through some difficult moments.

Most of all, *Ambler* would never have happened without the patience, guidance, and inspiration of my wife, Eve, who bravely climbed across mountains of photographs, files, reference books, and assorted papers to see me; who suggested solutions to logistical problems that once had me stymied; and who continues to be the best friend a man could ever hope for.

INTRODUCTION

Beginning slowly like the headwaters of the Wissahickon, which gradually gains speed as it surges toward the Schuylkill, Ambler seems to mirror perfectly the steady metamorphosis of the United States. A humble but proud working-class community, Ambler can trace its roots to the Harmers, a hardy Quaker family who emigrated from England to the New World in 1682 to seek religious freedom. The Harmers purchased land from William Penn and settled along the fertile banks of the Wissahickon (the Lenni Lenape word for "where the catfish jump"). It is there that William Harmer built the first gristmill, thereby initiating Ambler's first industry.

Nine mills soon mushroomed along the creek, providing the region with plenty of flour, lumber, and cloth. To accommodate the growing commerce, Harmer and others sought permission from the Crown to build a public road. Hence, by 1739, Butler Pike, the main thoroughfare of the town then called Wissahickon, was born. The milling industry did not run out of steam until the 1880s. Its death knell was tolled by the rumbling success of rail transport and the usurpation of waterpower by steam technology.

By 1855, the North Penn Railroad had begun chugging into Wissahickon Station, introducing the industrial age, with all its growth potential and problems, to the once agrarian community. The railroad assured the locals that more businesses would soon follow. However, before this could happen, the town experienced the greatest catastrophe to that point in American railroad history.

On July 17, 1856, the northbound *Shackamaxon*, carrying mostly people from the city on a picnic excursion through the countryside, and the southbound *Aramingo* collided head-on on the curved single track between Fort Washington Station and Camp Hill Station (the now defunct Fellwick flag stop), leaving 59 persons dead and another 86 injured. The sickening din of crunching metal could be heard for miles around, drawing many volunteers to what is now called the Great Train Wreck.

One of the volunteers, a frail Quaker woman named Mary Ambler, who had been operating her deceased husband's fulling mill since 1850, walked two miles (by one account) to the crash site, bearing medical supplies and a calming, healing presence that helped direct the rescue effort. Thirteen years later, in honor of Mary Ambler's heroism on that fateful day, the railroad renamed the local station Ambler. The post office soon echoed the railroad's gesture, and when the community was finally incorporated in 1888, it, too, took the name of Ambler.

In 1881, ironically enough, just as the milling industry began to crumble, the well-known pharmaceutical firm of Keasbey & Mattison decided to relocate its headquarters from

Philadelphia to Ambler. In 1882, the community's award-winning newspaper, the *Ambler Gazette*, printed its first edition. Thanks to the independently wealthy Henry Keasbey (who would ultimately become a silent partner) and the indefatigable spirit of the scientist Richard V. "Doc" Mattison, the news of Ambler's growth would soon spread round the world.

After repeated experiments in the final decade of the 19th century, Mattison had discovered the insulating properties of magnesium carbonate (an extract of dolomite, a rock mineral in plentiful supply just outside Ambler), especially when used in combination with asbestos. So, his company began manufacturing asbestos paper, millboard, and shingles. The demand for the new insulation products exploded so rapidly that Mattison's brilliant entrepreneurial vision soon began transforming Ambler into the quintessential company town.

To build the business, as well as the town that would shelter his burgeoning workforce, Mattison hired laborers from France, Germany, Poland, Hungary, and Ireland and African Americans from Westmoreland County, West Virginia. Perhaps his greatest contribution to Ambler's long-term life was importing countless Italian stonemasons and builders from the Calabrese town of Maida, with more coming from Minturno, near Naples (much of the Italian immigrant experience is chronicled in Gay Talese's book, *Unto Thy Sons*). At the start of the 20th century, with the help of these workers, Mattison created modern-day Ambler.

By building 400 homes in the area, 80 percent of which still stand today, Mattison in effect created a class system. From the brick row houses along Church Street for his blue-collar workers (rented to them at low rates) to the twin houses along Highland Avenue for his supervisors to the magnificent stone mansions on Lindenwold Terrace (constructed of sturdy stone from his own quarries) for his executives, plus his own 24-acre baronial estate named Lindenwold, Mattison left behind an unparalleled architectural legacy. In addition, he built the streets and Trinity Memorial Episcopal Church, improved the town's water supply and introduced electric streetlights, enhanced culture by building Ambler's first opera house and library and sponsoring plays and other entertainment, and generally took good care of his employees.

By the beginning of World War I, Ambler had become the asbestos capital of the world. The prosperity continued until the Great Depression forced Mattison to sell the company.

Ambler, however, did not fold. Because of its hardworking populace and community spirit, the strength of the borough's many fine churches, schools, and civic institutions—from the Wissahickon Fire Company and the Sons of Italy lodge to the Wissahickon Valley Historical Society to Main Street Ambler—this humble working-class community in Montgomery County, just 15 miles north of Philadelphia, has grown up gracefully with the reputation of being "a good place to raise a family."

In fact, partly because of its fine new restaurants, its recently built professional theater (Act II Playhouse), its newly reopened three-screen Ambler Theater, its 52-year-old Ambler Symphony Orchestra, and thriving businesses, Ambler was named in the April 2003 issue of *Philadelphia* magazine as one of the "10 Cool Neighborhoods (You've Never Heard Of)." This pictorial history is a modest attempt to invite readers to visit this lively community to discover for themselves why the face of Ambler remains so fair and why it reflects so well the steady growth of a great nation.

One

WISSAHICKON CREEK

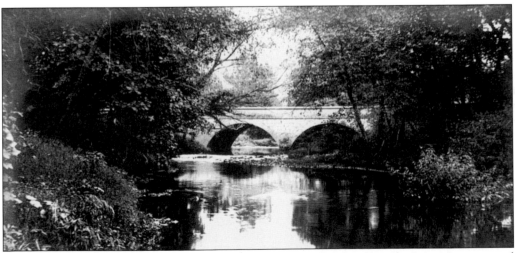

A stone bridge on Butler Avenue spans the Wissahickon Creek, where the Lenni Lenape used to fish before the Harmer family arrived from England in 1682. Here, the Harmers established the first mills, Ambler's first important industry. Now gone, the bridge was located near Reiff's Mill. (Courtesy of Wissahickon Valley Historical Society, c. 1906–1907.)

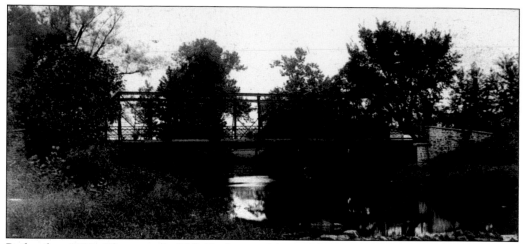

Built after 1900, Thompson's Mill Bridge on Mount Pleasant Avenue was a graceful iron structure. It was eventually replaced by a concrete bridge. (Courtesy of Wissahickon Valley Historical Society, *c.* 1906.)

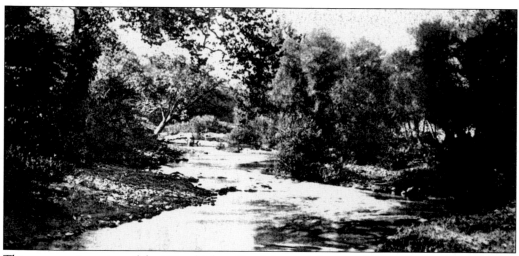

This summertime view of the Wissahickon Creek beyond the now defunct Butler Avenue stone bridge shows the creek in a mellow mood. Yet, it generated sufficient force to power up at least eight gristmills, a fulling mill, and a sawmill over the course of 200 years. (Courtesy of Wissahickon Valley Historical Society, *c.* 1908.)

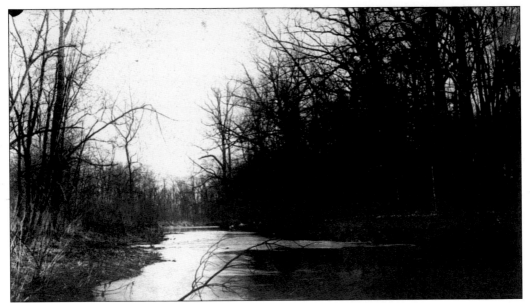

Just as autumn strips the trees bare, the onset of steam technology soon rendered the water-powered Wissahickon mills obsolete. By 1887, the last mill—Hague's Mill, off Bethlehem Pike near Hague's Mill Road—closed, bringing Ambler's long, proud milling era to an end. (Courtesy of Wissahickon Valley Historical Society, *c.* 1911.)

Men and women are not the only creatures to enjoy the largesse of the Wissahickon, as these duck pens on the banks of the creek in Ambler will attest. Canada geese, swans, pigeons, and all manner of water fowl find the creek a pleasant place to nest, rest, hunt, and swim in all seasons. (Courtesy of Wissahickon Valley Historical Society, *c.* 1913.)

Shown is Sallie Reiff, a descendant of the Reiff family who owned and operated the gristmill that was erected at Butler Pike and Reiff's Mill Road between 1731 and 1747. Under the name of Rose Valley Mills, the company shipped huge quantities of flour to distant points around the country. The mill stopped operating *c.* 1884, although the family continued to reside there for many years. (Courtesy of Wissahickon Valley Historical Society.)

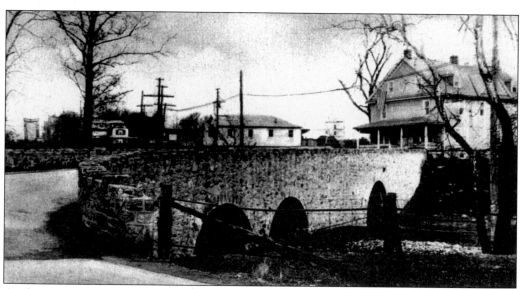

At the far right, redesigned by Richard V. Mattison, is the house built on the remains of old Reiff's Mill. The original stone walls and foundation still stand, the last remnants of Ambler's milling days. The curved bridge on Butler Pike is also gone, and Butler now runs straight through to Morris Road. The Welcome Home Monument (center left), erected after the end of World War I, no longer exists. (Courtesy of Wissahickon Valley Historical Society, *c.* 1920.)

Two
Mary Ambler
and the Railroad

For her heroic efforts to bring medical and emotional relief to the victims of the horrific train crash of July 17, 1856, the former Mary Johnson of Bucks County was destined to have her adopted town named in her honor. Her husband, Andrew Ambler, a weaver by trade, took ownership of the fulling mill in 1829 and operated it until his death in 1850, when Mary Ambler and her married son, Lewis Ambler, assumed control. She died in 1868. The next year the station name was changed from Wissahickon to Ambler, and in 1888, when the town was incorporated, Ambler borough was born. Not bad for a seemingly frail Quaker lady. (Courtesy of Wissahickon Valley Historical Society.)

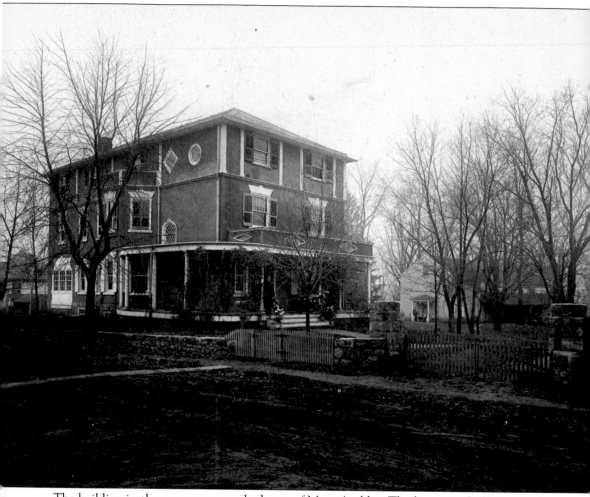

The building in the rear was once the home of Mary Ambler. The house in the foreground was constructed from what was originally the barn, with its bridge extending toward the Ambler home. It was the residence of printer Joseph Johnson, who was related to and knew the Ambler sons. (Courtesy of Wissahickon Valley Historical Society, c. the 1890s.)

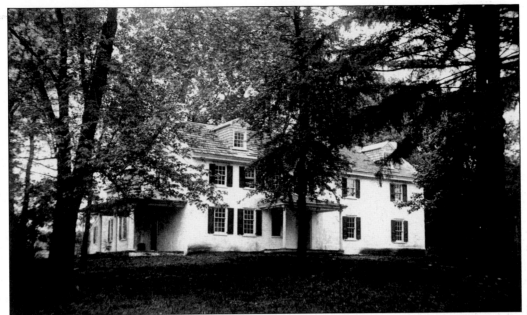

Pictured in the springtime is the west side of the Mary Ambler Homestead. Located at the intersection of Main Street and Tennis Avenue, it is one of the oldest homes still standing in Ambler borough. Following the Great Train Wreck of July 17, 1856, Mary Ambler allowed her home to serve as a temporary hospital for countless victims of the wreck. (Courtesy of Wissahickon Valley Historical Society, c. 1925.)

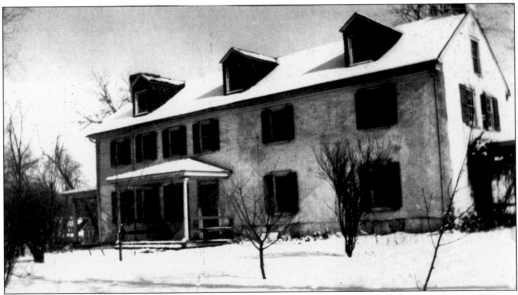

What a difference a season makes. Here is another view of the west side of the Mary Ambler Homestead taken a few months later, just after a light snowfall. More visible here are the family porch and the three dormers along the roofline. The interior contained large fireplaces, a Dutch oven, and arched vaults in the cellar, where root vegetables were stored. (Courtesy of Wissahickon Valley Historical Society, c. 1925.)

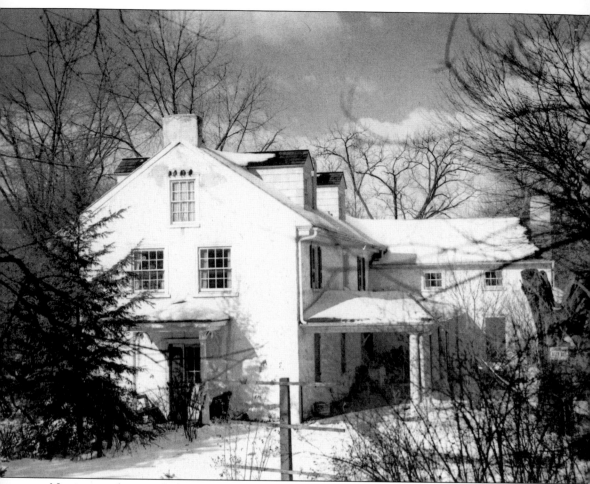

Now privately owned, the Mary Ambler Homestead was originally built in the early part of the 18th century. The date stone in the peak just below the chimney indicates that Andrew and Mary Ambler took possession of the house in 1831. (Courtesy of Wissahickon Valley Historical Society, *c.* 1950.)

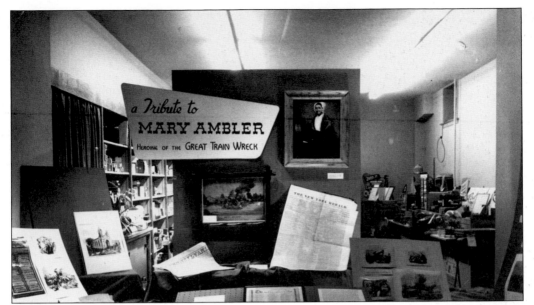

This photograph, originally from the archives of the Wissahickon Valley Public Library, shows "A Tribute to Mary Ambler: Heroine of the Great Train Wreck." Several local institutions have paid their tribute over the years, including the library and the Wissahickon Valley Historical Society. (Courtesy of Wissahickon Valley Historical Society.)

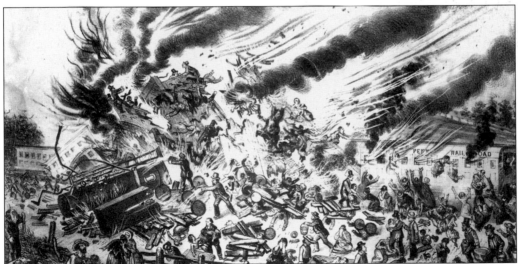

In 1956, on the 100th anniversary of the Great Train Wreck, J.N. Mears of Blue Bell printed this fanciful rendering of the catastrophe. The smoke rising from the twisted and mangled trains looks like two tornadoes, and several of the figures bear the mark of high melodrama, which is not to minimize the severity of the accident. The collision caused three cars to be piled up on the engine of the outbound train, claimed 59 lives, and injured nearly 100 people, most of whom were among the 1,000 passengers on the excursion train. (Courtesy of Wissahickon Valley Historical Society.)

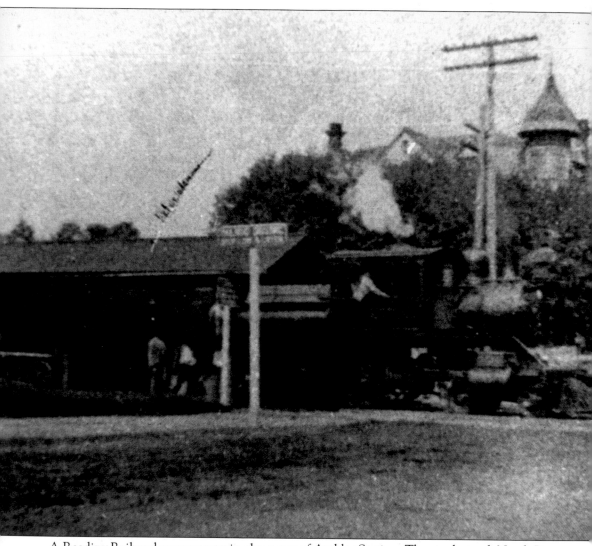

A Reading Railroad passenger train chugs out of Ambler Station. The single-track North Penn Railway line was completed in 1855. Its Reading line was soon running excursion trains into the countryside to allow Philadelphians to escape the city for a short time. The old Hotel Ambler, visible in the upper right, was built to accommodate the influx of travelers into Ambler and the Gwynedd Valley. (Courtesy of Wissahickon Valley Public Library, 1905.)

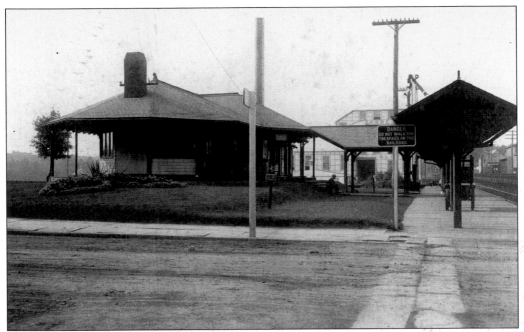

When the railroad arrived in 1855, the town's center of gravity shifted from the crossroads at Bethlehem and Butler Pikes to the western end of Butler Avenue. Shown is a quiet moment at Ambler Station. Notice the Keasbey & Mattison asbestos plant just beyond the station house. (Courtesy of Wissahickon Fire Company, c. 1900–1910.)

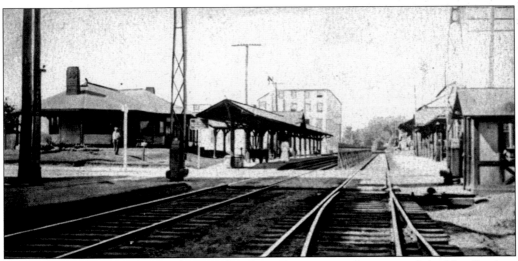

The double tracks of the Reading Railroad can be seen in this view of Ambler Station. Although double tracks might have prevented the Great Train Wreck of 1856, the second set of tracks was not completed until 1873, to accommodate the huge crowds arriving for the semiannual agricultural fairs organized by the Montgomery County Agricultural Society starting in 1870. Thousands would flock to Ambler each day of the week-long fair. (Courtesy of Wissahickon Valley Historical Society, c. 1905.)

The house at 77–79 East Butler Pike was the home of hardworking Charles Weikel Gerhart Sr., who owned a livery, freight, and coach service. Protected by the overhangs in front of the house are two hacks used by Gerhart to meet the inbound and outbound trains and to take his passengers as far away as Willow Grove Park. It eventually became Lapetina's Furniture Store, which was destroyed by fire on a snowy night, February 14, 1962. The Lapetina family rebuilt the store, which later became Regan's Shoe Store. That, too, has closed. (Collection of Ross Gordon Gerhart III, c. 1910–1920.)

Railroads debarking from Ambler Station shipped much milk to points near and far. This South Main Street cattle ramp was used to prod cattle onto trains. It was destroyed in the late 1960s. (Photograph by Sam Jago, courtesy of Wissahickon Valley Historical Society, c. 1960.)

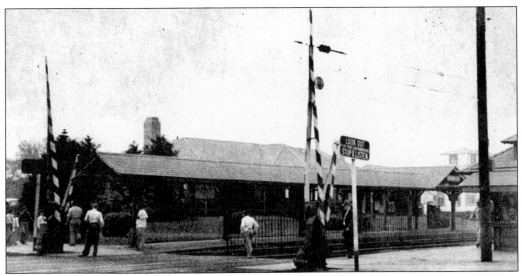

This view of Ambler Station shows passengers awaiting their trains. At its height on any given day, the Reading Railroad might send through as many as 48 passenger trains, 10 of them express trains. (Courtesy of Wissahickon Valley Historical Society, c. 1950.)

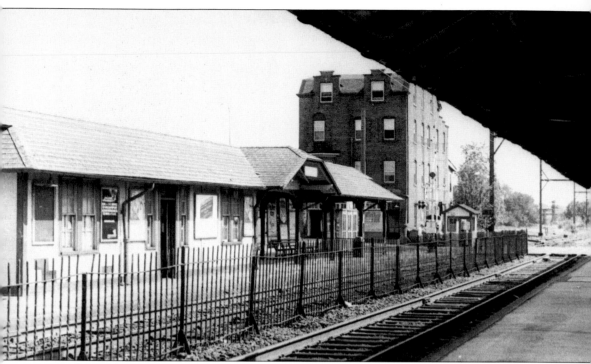

Looking inbound, this view of Ambler Station shows Ambler Palace, an ice-cream parlor and a confectionery (now gone), across Butler Avenue from two mainstays of modern-day Ambler—a McDonald's and the Trax Restaurant & Café, chef-owner Steve Waxman's popular American-style bistro that helped launch Ambler's recent restaurant revival. (Courtesy of Wissahickon Fire Company, 1976.)

Three

THE KEASBEY-
MATTISON ERA

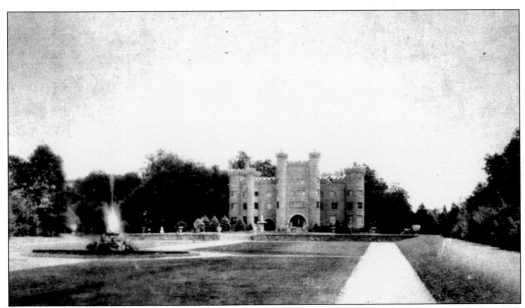

Looking like a grand estate in the British countryside, Lindenwold was the home of Richard V. Mattison, the man whose vision and fierce entrepreneurial spirit essentially created the Ambler that still exists today. Sprawling along Bethlehem Pike between Highland Avenue and Lindenwold Terrace, it was built at the end of the 19th century. Elaborate stonework added to the exterior in 1912 gave it a castlelike appearance reminiscent of England's renowned Windsor Castle. (Courtesy of Wissahickon Valley Historical Society, the 1920s.)

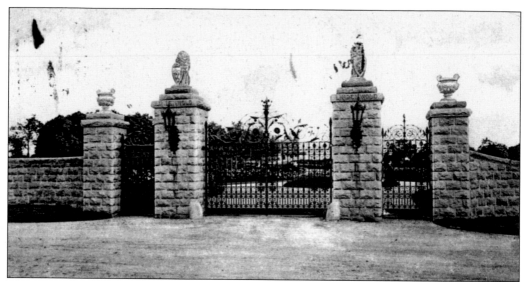

Here is Lindenwold gateway. The iron gates at the entrance were designed by an artist in Munich, Germany, but executed at a local firm in Ambler called Ornamental Ironworks (today, the Boiler Erection Company). The estate also had two smaller entrances, each with its own gatehouse. (Courtesy of Wissahickon Valley Historical Society, *c.* 1906.)

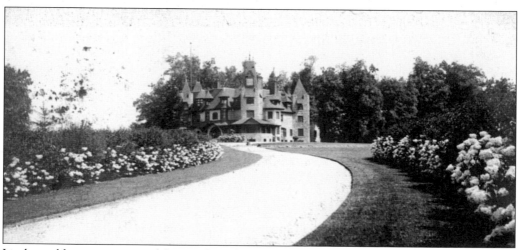

Lindenwold was crisscrossed by winding driveways bordered by variegated flower beds. This driveway would take guests to the entrance of the Mattison family's 24-room mansion, adorned with six towers and surrounded by untold acres of lawns, formal gardens, and a lake. (Courtesy of Wissahickon Valley Historical Society, *c.* 1906.)

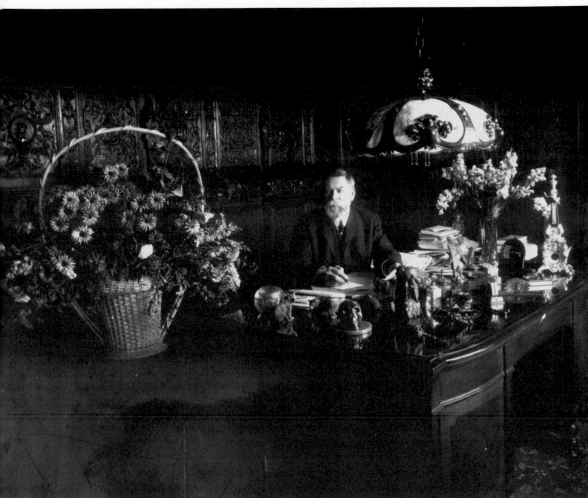

Richard V. Mattison, the man who literally put Ambler on the map, sits at his desk in his office at Lindenwold. A country squire? A baron? An industrial genius? A civic-minded pioneer? A brilliant rose with deadly thorns? The 73-year-old scientist and community leader whose efforts helped bring about the incorporation of Ambler borough in 1888 was all of these and more. Many loved him; many more hated him, but none can deny that his partnership with the independently wealthy Henry G. Keasbey, a member of one of America's oldest families, made Ambler what it is today. (Courtesy of Wissahickon Valley Historical Society, 1923.)

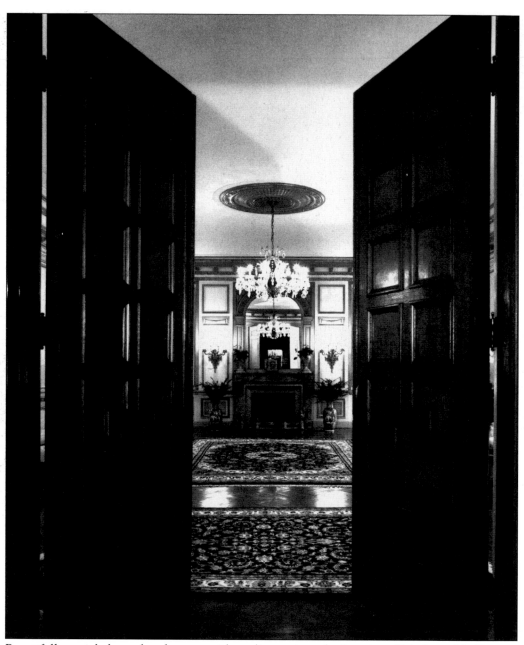

Beautifully paneled wooden doors provide a glimpse into the interior of Lindenwold. German craftsmen did much of the woodwork for Mattison, who employed a small army of interior decorators, carpenters, electricians, plumbers, cabinetmakers, kitchen staff, office help, gardeners, blacksmiths, harness makers, carriage painters, farmers, and dairymen. His payroll could run as high as $10,000 a week. (Historic American Building Survey, courtesy of Wissahickon Valley Historical Society, c. 1992.)

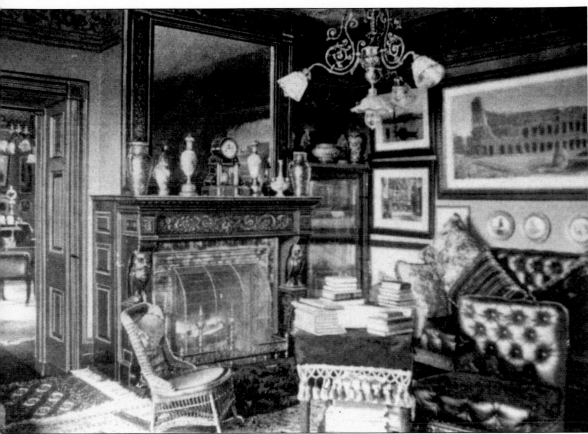

Looking very much lived in, with its fireplace, rocking chair, leather couch, and stacks of books on the end table, the room shown in this photograph offers another look into the private world of Richard V. Mattison. The entrepreneur lived at Lindenwold most of his married life, first with his first wife, Esther, of Cranbury, New Jersey, whom he married in 1874, and their three children, Esther Victoria, Richard Jr., and Royal. Esther Mattison died at the family's Newport, Rhode Island, estate in 1919. The following year, Mattison married his late wife's dear friend Mary E.C. Seger of Princeton, New Jersey. (Courtesy of Wissahickon Valley Public Library.)

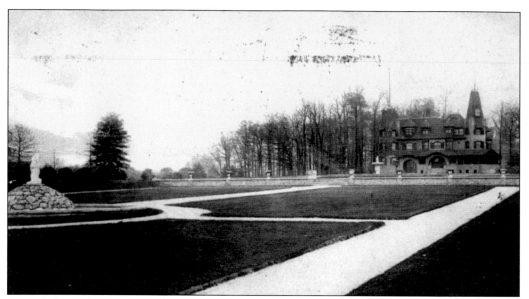

On a clear day, one could walk almost forever across 50 acres of well-tended Lindenwold lawns. The lush and lovely grounds of the Mattison estate were also highlighted by winding driveways, stone statuary, ornamental stone walls, sunken gardens, and a six-acre lake called Loch Linden. (Above, courtesy of Wissahickon Valley Historical Society, *c*. 1910; below, courtesy of Wissahickon Valley Public Library.)

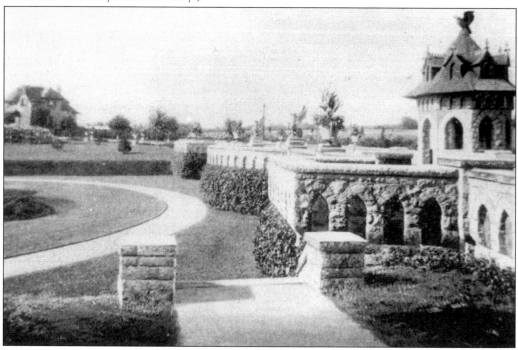

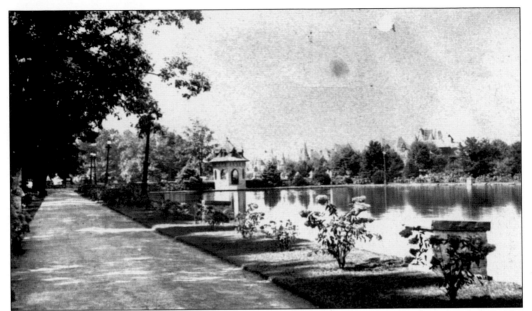

Behind the mansion, Richard V. Mattison had his own private lake. Sounding very much like one of its natural counterparts in the Scottish Highlands, the pleasure lake is called Loch Linden. A cannon from the grounds of Lindenwold now resides in one of the museums of the Smithsonian Institution in Washington, D.C. (Courtesy of Wissahickon Valley Historical Society, c. 1908.)

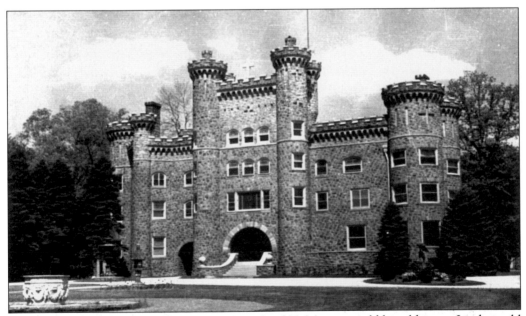

On January 1, 1936, the year that he died, Richard V. Mattison sold his old estate Lindenwold to the Catholic Sisters of the Holy Family of Nazareth for $115,000. By September 1936, the nuns had converted the mansion into St. Mary's Villa for Children. Note the crucifix between the two towers above the entranceway. St. Mary's Villa still cares for orphans, between 100 and 140 today. (Courtesy of Wissahickon Valley Historical Society, c. the 1950s.)

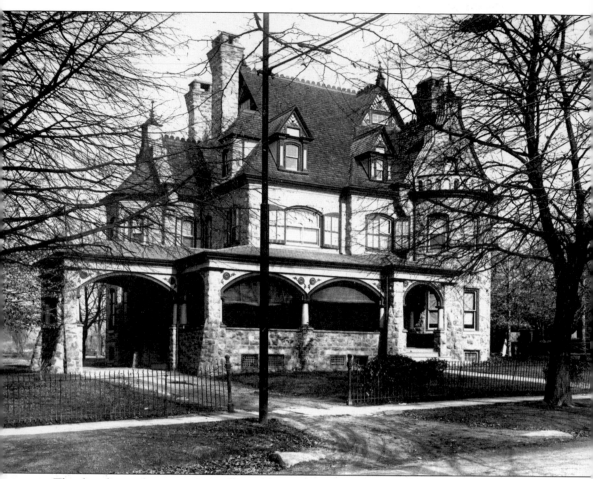

This handsome house at 3 Lindenwold Terrace, with its porte-cochere, archway porch, and Victorian flourishes, is now known as the Vika Home. Like all the homes along Lindenwold Terrace, it was built for executives high up in the Keasbey & Mattison hierarchy. For several years before his death on the evening following his 85th birthday, Mattison himself lived just two houses away, at 1 Lindenwold Terrace, at the corner of Bethlehem Pike. (Courtesy of Wissahickon Valley Historical Society.)

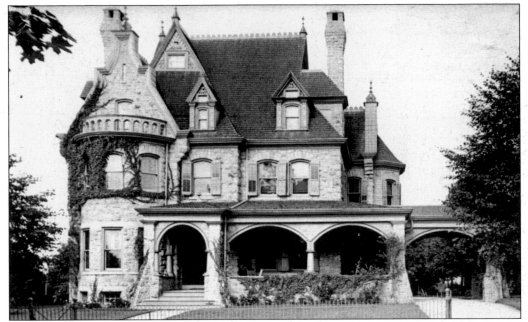

This two-and-a-half-story stone edifice at 6 Lindenwold Terrace was built in 1898 for J.B. Eckfeldt, a prominent executive with Keasbey & Mattison. (Courtesy of Wissahickon Valley Historical Society, c. 1912.)

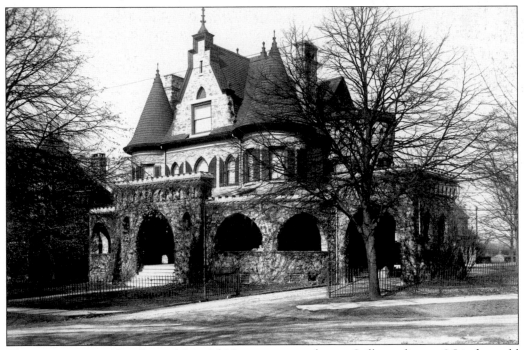

This is not just another beautiful grand Victorian stone house. Still standing at 8 Lindenwold Terrace and privately owned, Lindengate House, built in 1898, was the wedding gift of Richard V. Mattison for his son Royal Mattison in 1912. (Courtesy of Wissahickon Valley Historical Society, c. 1912.)

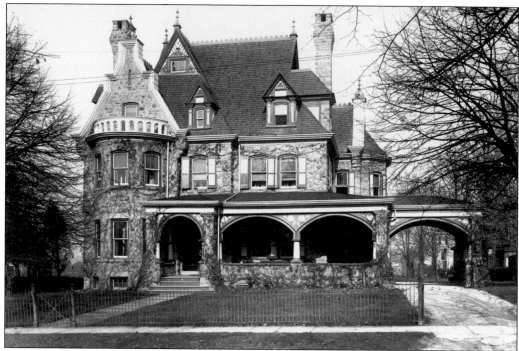

Visitors to Ambler cannot seem to get enough of these extraordinary stone houses along Lindenwold Terrace built for top executives at Keasbey & Mattison. This home was once the property of Walter O. Ford. (Courtesy of Wissahickon Valley Historical Society, c. 1912.)

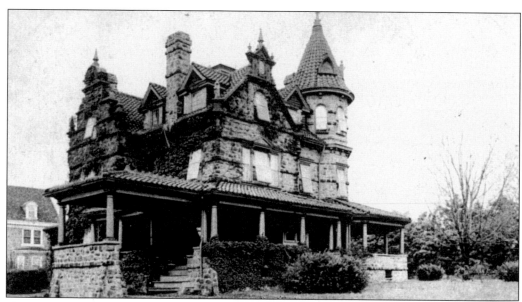

Shown in this familiar and once popular postcard view is the elaborate stone edifice known as the Towers. Located at Bethlehem Pike across from Trinity Memorial Episcopal Church, it was built by Richard V. Mattison for his son Richard Mattison Jr. (Courtesy of Wissahickon Valley Historical Society, c. 1930.)

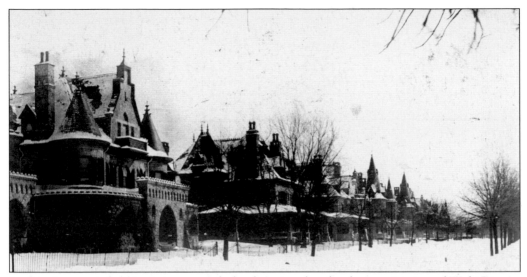

Looking very much like a winter wonderland conjured up by the imagination of Walt Disney, this is a charming view of fabled Lindenwold Terrace from Bethlehem Pike to Cedar Road, where Richard V. Mattison's top executives must have felt it was Christmas every day. (Courtesy of Wissahickon Valley Historical Society, *c*. 1907.)

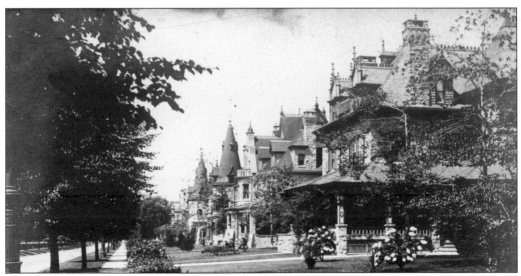

The springtime view of Lindenwold Terrace from Cedar Road to Bethlehem Pike could not have diminished the affection of Mattison's most important executive officers for their eccentric employer. (Courtesy of Wissahickon Valley Historical Society, *c*. 1907.)

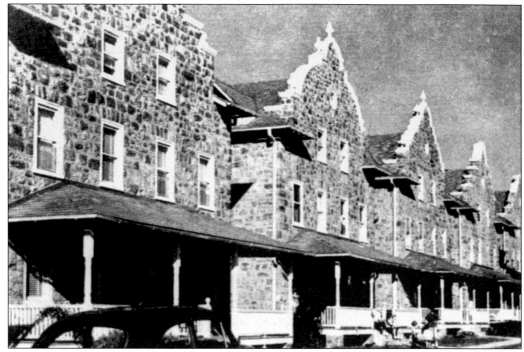

To maximize efficiency and exert a more powerful hold over his employees, Richard V. Mattison in effect created a caste system. He had 400 homes built in Ambler at the beginning of the 20th century. Stone twins such as these were erected along Highland Avenue and upper Church Street for Mattison's foremen. (Courtesy of Wissahickon Valley Public Library.)

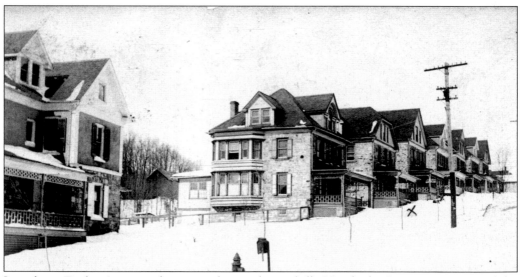

Just above Butler Avenue, these twin houses lining hilly Hendricks Street were some of the dwellings built for middle managers during the Keasbey-Mattison era. (Courtesy of Wissahickon Valley Historical Society, c. 1908.)

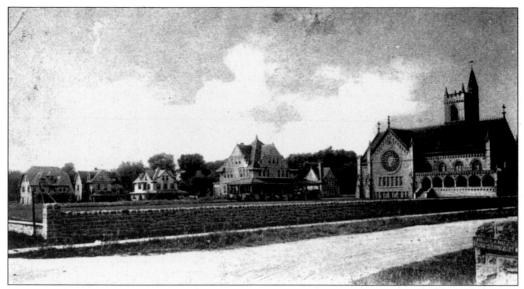

Trinity Green was so called because of the lovely lawn as well as the dominating position of Trinity Memorial Episcopal Church, built by Richard V. Mattison on Bethlehem Pike between Highland Avenue and Church Street. In this postcard view, directly to the left of the church is the gatehouse and next to it is the rectory. The homes farther to the left are typical of those Mattison constructed for his superintendents. (Courtesy of Wissahickon Valley Historical Society, c. 1907.)

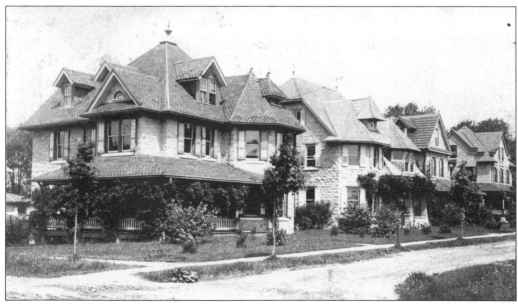

Behind Trinity Memorial Episcopal Church are several more sturdy homes built for Richard V. Mattison's middle-management team. Blue-collar workers, on the other hand, lived in row houses along lower Church Street. (Courtesy of Wissahickon Valley Historical Society, c. 1906.)

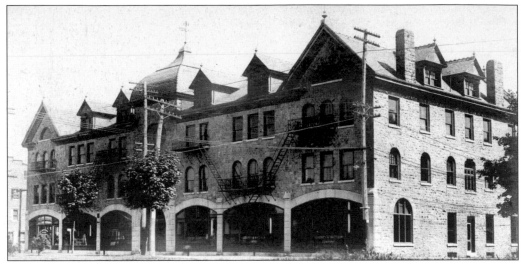

Built in 1890 on the south side of Butler Avenue just west of the railroad tracks is the Opera House, a huge building that served not only as an entertainment center for Ambler but also as the site of important Keasbey & Mattison Company offices and rooms for other businesses. At various times, it also housed the post office, the library, and other civic institutions. (Courtesy of Wissahickon Valley Historical Society, *c.* 1906.)

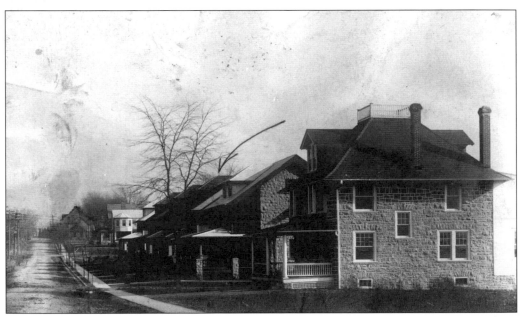

This is another block of Mattison-era homes, built for middle-management types along Mattison Avenue. Although the Keasbey & Mattison Company paid relatively low wages to its employees, the rentals for these houses were much lower than the rates being asked by other property owners in the area. (Courtesy of Wissahickon Valley Historical Society, *c.* 1913.)

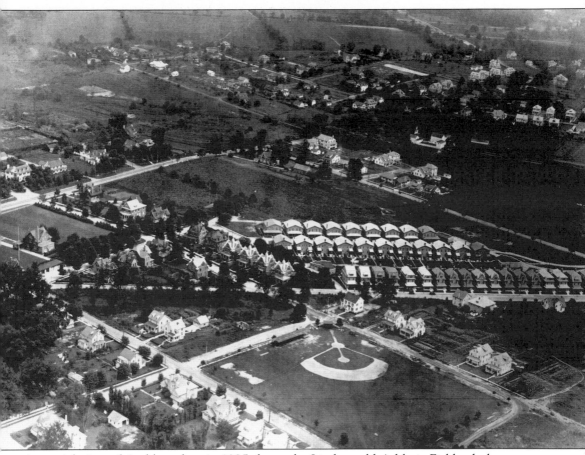

An aerial view of Ambler taken in 1925 shows the Lindenwold Athletic Field, whole streets with similar housing for specific castes of employees of the Keasbey & Mattison Company, and (top left) a glimpse of the Asbestos Shingle, Slate & Sheathing Company. (Courtesy of Wissahickon Valley Historical Society.)

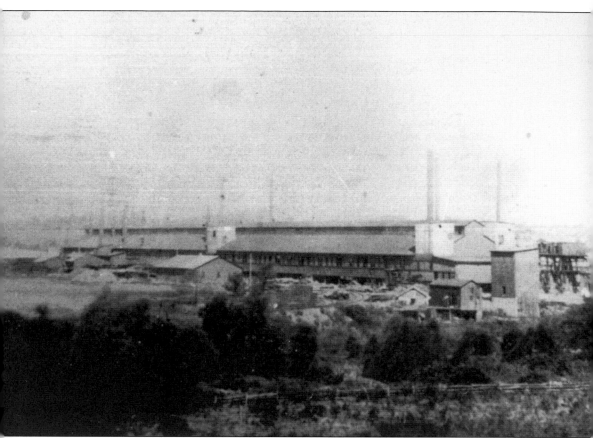

The partners Henry Keasbey and Richard V. Mattison graduated from Philadelphia College of Pharmacy in 1873 and soon opened a small pharmaceutical laboratory in Philadelphia, producing Bromo caffeine, milk of magnesia, and similar products. In 1881, seven years before the town was incorporated, they moved their whole operation to Ambler, where chemical whiz Mattison, after repeated experiments, discovered the insulating properties of asbestos. The success of Keasbey & Mattison stimulated industrial production in plants such as this, located in Upper Dublin Township, where Ambler and nearby Whitemarsh Township are situated. (Courtesy of Wissahickon Valley Public Library.)

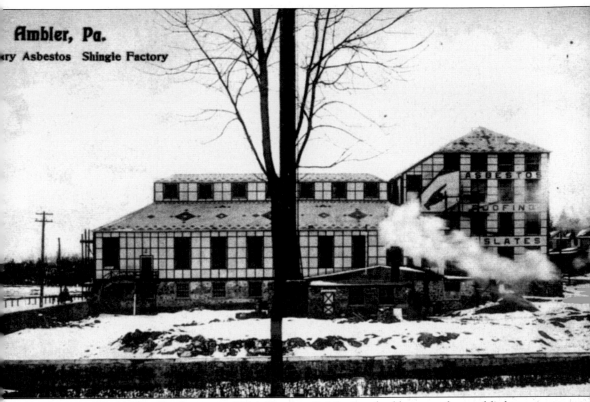

Ambler, Pa.

ry Asbestos Shingle Factory

ASBESTOS
ROOFING
SLATES

By the time World War I broke out in 1914, Keasbey & Mattison had become the world's largest manufacturer and supplier of asbestos products. The peak years were from 1910 to the 1920s. Just down the road from Ambler Station was the Century Asbestos Shingle Factory, one of the borough's most important plants. (Courtesy of Wissahickon Valley Historical Society, c. 1910.)

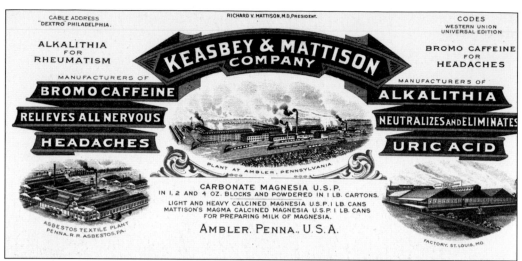

This Keasbey & Mattison Company letterhead shows the scope and range of the company's activities. The company produced everything from headache and stomach relief products (in its early years) to asbestos insulation and related products. The asbestos plants were huge. One of the company's advertising slogans was "Lest we forget—'the BEST in asBESTos'." (Courtesy of Wissahickon Valley Historical Society.)

The Band Pavilion, located at the site of today's McDonald's at Butler Avenue and Maple Street, was a reminder that Richard V. Mattison had not forgotten the townsfolk. He not only brought jobs and culture to Ambler but also spearheaded the incorporation effort, introduced street lighting, built Ambler's first water system, and participated in everything that mattered in the thriving borough. (Courtesy of Wissahickon Valley Historical Society, c. 1923.)

In this dramatic photograph, the Wissahickon Fire Company is putting out a brush fire on "White Mountain," a hill of asbestos debris at Locust and Center Streets left over from the Keasbey-Mattison era. In 1984, the Environmental Protection Agency ultimately mandated that all 25 acres of asbestos waste (1.5 million cubic yards) located in south Ambler and the adjoining Upper Dublin Township be covered with dirt and grass and fenced in. Still, asbestos has been discovered to be a carcinogen and is known to cause asbestosis, a lung disease similar to emphysema that now afflicts many former employees of the Keasbey & Mattison Company. It is believed that the dangers of asbestos were known to the company at least as early as 1900 but that the knowledge was suppressed. (Courtesy of Wissahickon Fire Company, 1975.)

Richard V. Mattison had Ambler's first opera house designed and built by Marvin Beans of Lansdale in 1890, bringing a new wave of theater, vaudeville, and later, when vaudeville died, moving pictures. Located on the south side of Butler Avenue to the west of the railroad tracks, it also housed at various times the post office, the library, and other businesses. (Courtesy of Wissahickon Valley Historical Society, c. 1907.)

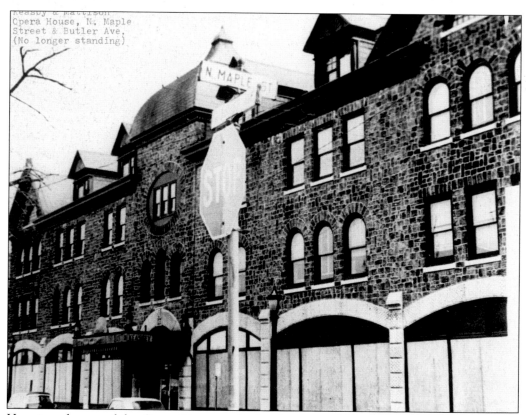

Here is a closeup of the Opera House, at Butler Avenue and North Maple Street. In its first decade of use, it certainly validated the popular description the Gay Nineties. (Courtesy of Wissahickon Valley Public Library.)

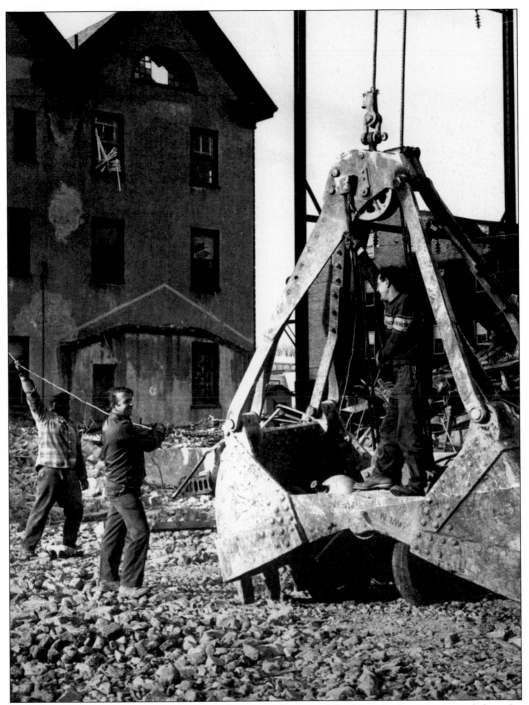

By 1966, the Opera House had outlived its usefulness and had become a prime candidate for the wrecking ball. Pictured here is a team of laborers razing the venerable old building. (Courtesy of Wissahickon Valley Historical Society, 1967.)

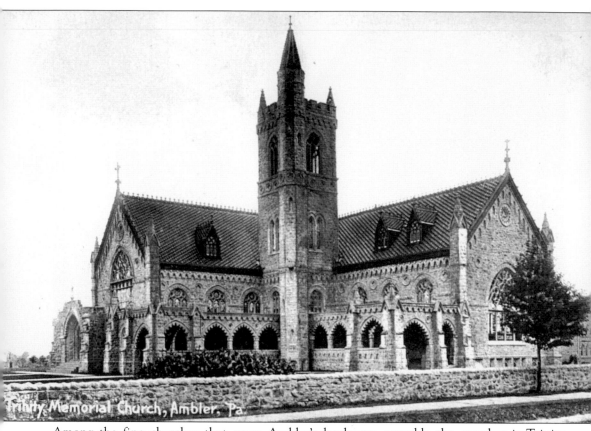

Trinity Memorial Church, Ambler, Pa.

Among the fine churches that grace Ambler's landscape, arguably the grandest is Trinity Memorial Episcopal Church. Established in 1891, it was built by Richard V. Mattison to honor the memory of his daughter Esther Victoria, who had died suddenly at the age of four. The erection of the church, which began as a mission organized by Rev. Samuel Snelling, rector of St. Thomas' Church of Whitemarsh, commenced in 1898, and the cornerstone was laid one year later. (Courtesy of Wissahickon Valley Historical Society, c. 1906.)

Four

CHURCHES
AND SCHOOLS

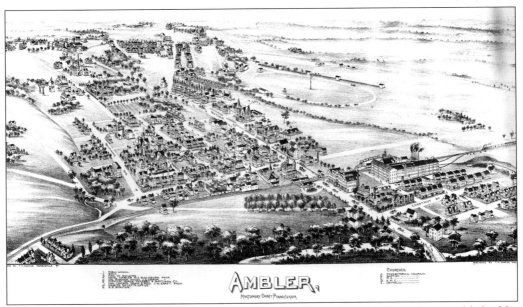

This remarkable map was drawn by T.M Fowler of Collegeville in 1894 and was published by Fowler and James B. Moyer. Of particular interest are the huge Keasbey & Mattison Company asbestos plant next to the railroad tracks (lower right), Richard V. Mattison's Lindenwold estate (top, just left of center), and St. Anthony's Roman Catholic Church on hilly Hendricks Street (top left). It is estimated that 80 to 90 percent of the houses and buildings erected by Mattison at that time and in the decade to follow are still standing today, more than 100 years later—a remarkable statistic by any reasonable standard.

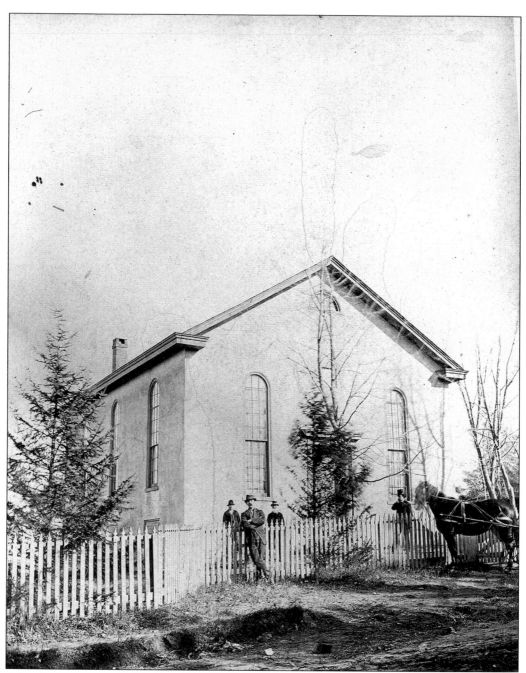

After the service, some of the more dapper faithful congregate outside Mount Pleasant Baptist Church, the oldest church in Ambler. With 25 members, it was established in 1834 on what was then known as Mount Pleasant Hill on Morris Road. Thomas and Hannah James donated three quarters of an acre of grounds for the church and burial site. Although the church building no longer stands, the cemetery remains. (Courtesy of Wissahickon Valley Historical Society, 1894.)

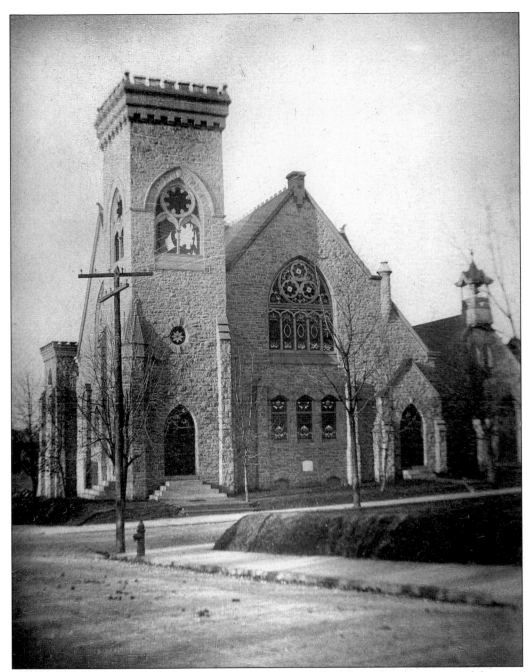

When the congregation began to outgrow its original building, this fine stone edifice was erected at the corner of Forest Avenue and North Spring Garden Street. It was begun in 1892 and dedicated the following year. The chapel to its right was built in 1877, when the membership had grown to 129. Both the chapel and the church are still standing. (Courtesy of Wissahickon Valley Historical Society, *c.* 1895.)

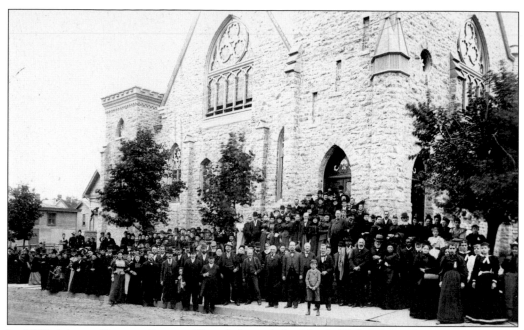

In 1908, Mount Pleasant Baptist Church hosted the North Philadelphia Baptist Association Meeting. However, this was the first such meeting in its new stone building. The congregation had grown to 137 members, with the Reverend Thomas G. Denchfield serving as the first pastor in the new building. (Collection of Ross Gordon Gerhart III, 1908.)

Decorated for Christmas before the installation of its new organ, Mount Pleasant Baptist Church takes on a more festive note for the holidays. (Collection of Ross Gordon Gerhart III, c. 1915–1925.)

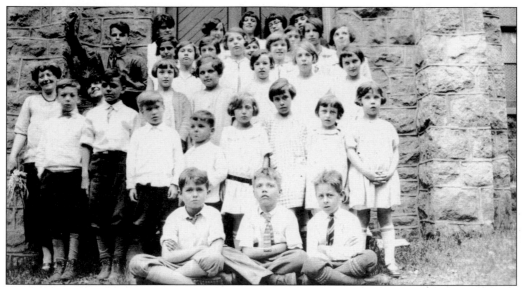

These little angels of Ambler are the children of the Sunday school class at Mount Pleasant Baptist Church in 1928. (Collection of Ross Gordon Gerhart III.)

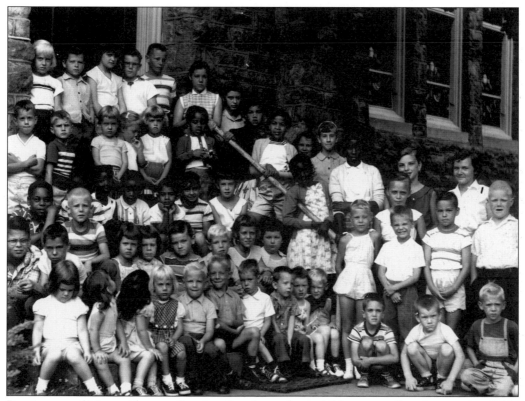

Pouring out of Mount Pleasant Baptist Church are these children attending the vacation Bible school during the summer of 1958 or 1959. (Collection of Ross Gordon Gerhart III.)

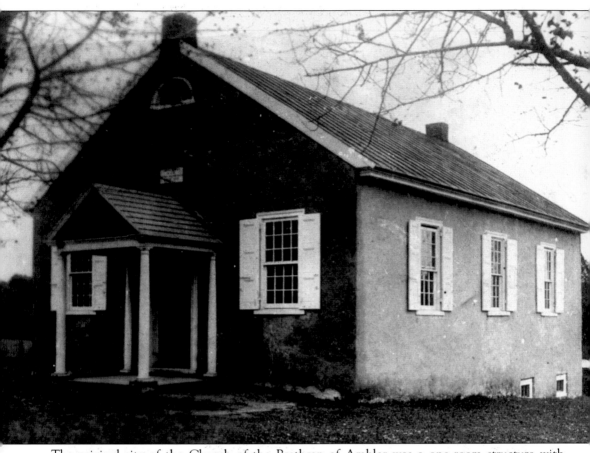

The original site of the Church of the Brethren of Ambler was a one-room structure with whitewashed walls that resembled Mennonite meetinghouses and churches of the Brethren in northern Montgomery County. Built in 1840 on land donated by John Reiff, it was situated on the east side of Butler Avenue near the end of Hague's Mill Road between the Rose Valley and Rose Hill Cemeteries. It was demolished in 1923. (Courtesy of Ambler Church of the Brethren, *c*. 1920.)

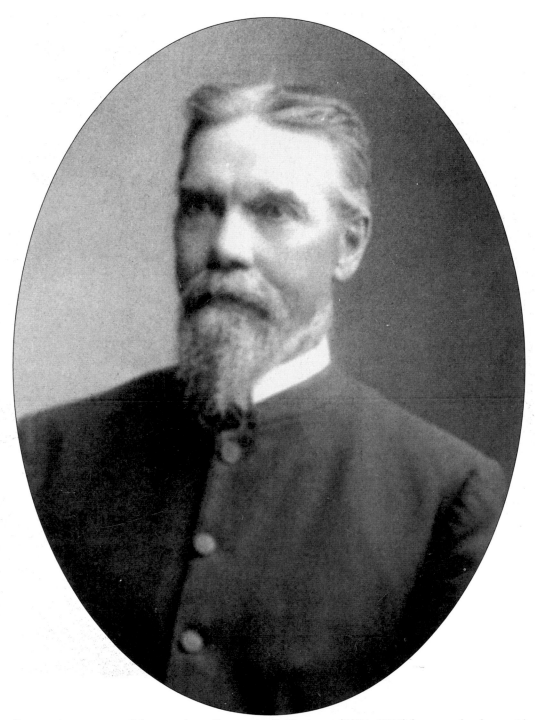

By unanimous vote of the members, Benjamin F. Kittinger (1894–1906) became the first paid minister in the history of Ambler's Church of the Brethren. His annual salary was $120, but he also received $215 for provisions. As the church was growing, the membership decided to hold services every week instead of every other week. (Courtesy of Ambler Church of the Brethren, c. 1899.)

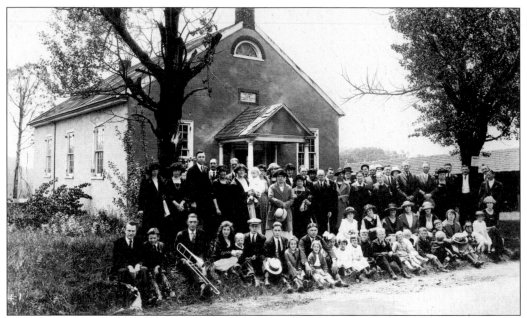

Members of the Upper Dublin Church of the Brethren gather outside their original one-room meeting place *c*. 1922, just before their move to the new building, when they also changed the name of the church to Church of the Brethren of Ambler. (Courtesy of Ambler Church of the Brethren.)

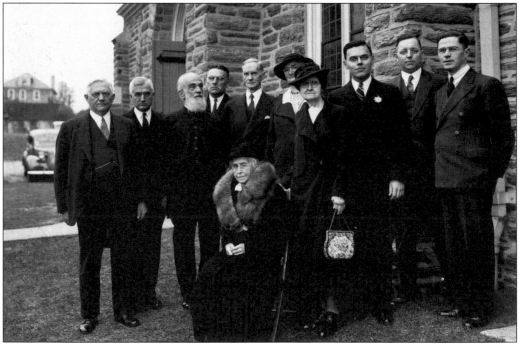

Gathered before the new Church of the Brethren building at Butler and Rosemont Avenues on October 27, 1940, are members of the 100th Anniversary Committee and their chosen speakers. The church was originally an outgrowth of the Upper Dublin German Baptist Church. (Courtesy of Ambler Church of the Brethren.)

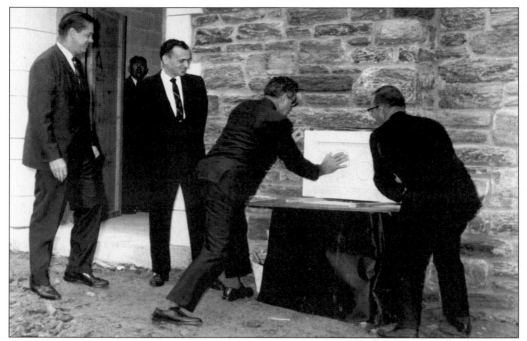

Laying the cornerstone of the new wing of Ambler's Church of the Brethren are the Reverend Donald Wayne Rummel (1960–1970, second from the left) and members of the building committee. (Courtesy of Ambler Church of the Brethren, c. 1967.)

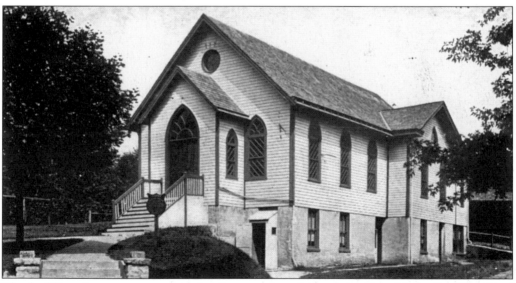

The building that once served as the first meeting place of the First Methodist Church of Ambler dates back to 1886. Located at one corner of Ridge Avenue and Race Street, the lot was purchased from John Redington for $1,000. The Reverend J. Wesley Perkinpine, who had been pastor of the Montgomery Square Methodist Episcopal Church, presided over the first service. After the church moved to a new location at Lindenwold and Park Avenues, the original building served temporarily as the borough's library and then as the home of the Colony Club. (Courtesy of Wissahickon Valley Historical Society, c. 1905.)

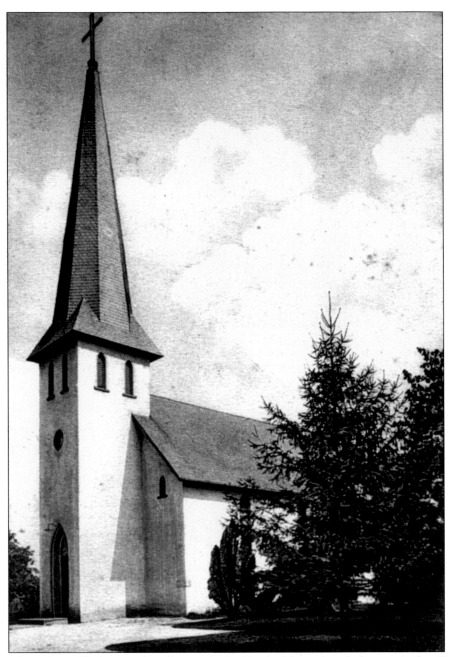

Despite the influx of Italian workers during the building of the railroad, there were few Catholic families in Ambler through the 1880s. After that number grew and several families had to walk all the way to Chestnut Hill to attend Sunday mass, the Reverend Henry Stommel, pastor of Our Lady of Mount Carmel Church in Doylestown (and builder of the Catholic churches in Lansdale, Quakertown, and Sellersville), founded St. Anthony of Padua Roman Catholic Church on Forest Street at the top of what is now hilly Hendricks Street in 1886. The impressive tower, saved during the catastrophic fire of 2000 that consumed the rest of the church, will become part of the new church building rising today just across the street from the original edifice. (Courtesy of Wissahickon Valley Historical Society, c. 1906.)

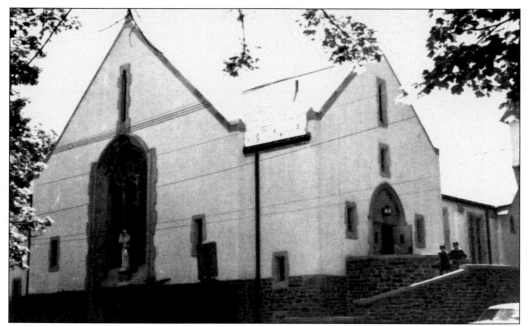

This is a view of the nave of the second St. Anthony of Padua Roman Catholic Church, dedicated in 1956, the 70th anniversary of the original structure. The nave of the old church became the chancel of this church. It was originally built on a country lane on the farm of Joseph Ambler. (Collection of Ross Gordon Gerhart III, c. the 1960s.)

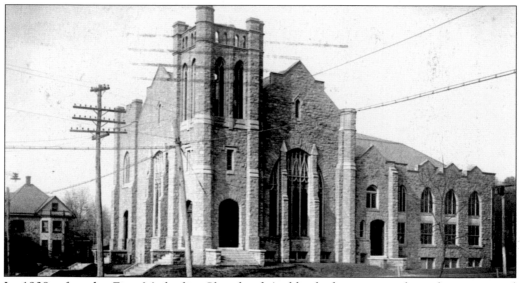

In 1908, after the First Methodist Church of Ambler had grown too large for its original quarters at Ridge Avenue and Race Street, the members purchased the vacant lot at Lindenwold and Park Avenues, where the present stone church (pictured here) was built. On September 4, 1912, the name of the church was changed to the Calvary Methodist Episcopal Church of Ambler, and on May 18, 1913, the church was formally dedicated. (Courtesy of Wissahickon Valley Historical Society, c. 1905.)

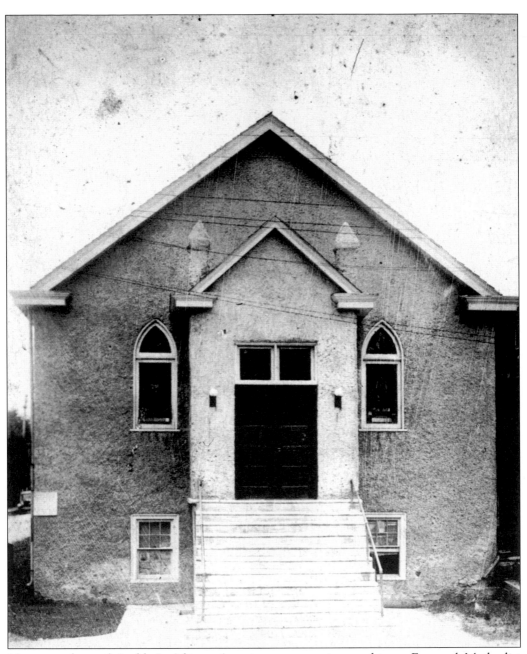

Many members of Ambler's African American community worship at Emanuel Methodist Church, situated at the intersection of Woodland Avenue and North Street. Organized in 1870 in Spring House, early members decided to move the church on wheels from its original site to a new lot on Poplar Street in Ambler. Heavy snows, however, forced them to settle in Penllyn until the following spring, when they finally reached Poplar Street. Construction on the current church (pictured here) was completed in 1907. (Courtesy of Wissahickon Valley Historical Society, 1936.)

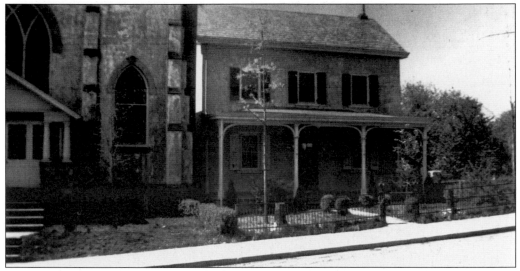

Looking every bit the typical country house it was when it was built in the mid-19th century, the parsonage of St. John's Evangelical Lutheran Church is one of the oldest standing structures in Ambler. Located at 26 North Ridge Avenue at Race Street on property owned by the Ambler family at the time, the parsonage currently bears a plaque that designates it a Montgomery County Historical Landmark. (Collection of Ross Gordon Gerhart III.)

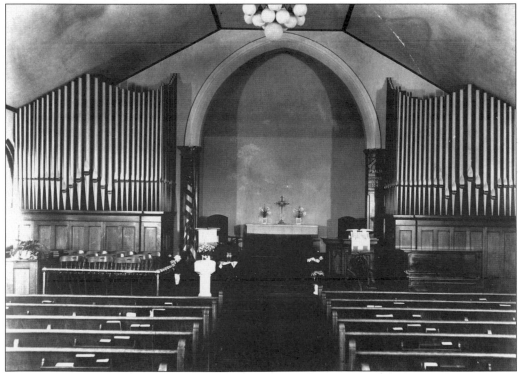

The chancel of St. John's Evangelical Lutheran Church stands on the northwest corner of Ridge Avenue and Race Street. The photograph was taken during the Easter season (note the palms and pots of flowers) after the installation of the church's first pipe organ and before the installation of the altar reredos and retable. (Collection of Ross Gordon Gerhart III, 1920.)

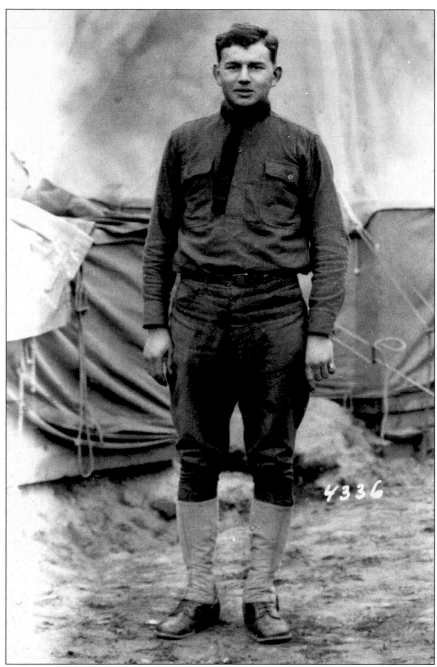

Lyman Rohr of Ambler, a charter member of St. John's Evangelical Lutheran Church, as well as its former Sunday school librarian, poses in front of his army tent in France during World War I. He was killed in an explosion during the Second Battle of the Marne in France on July 17, 1918, a battle that raged for three weeks and helped turn the tide of victory toward the Allies. Rohr sent the photograph to his girlfriend Mary Viola Scheetz, the grand-aunt of Ross Gordon Gerhart III, shortly before he was killed. A memorial bronze plaque to this American Legion flag holder can still be found in the front yard of the parsonage. (Collection of Ross Gordon Gerhart III.)

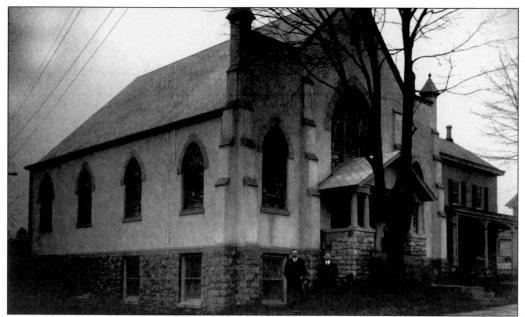

Two unidentified men are standing in front of St. John's Evangelical Lutheran Church. Founded by the Reverend Samuel F. Tholan, who was then the pastor of the Upper Dublin ("Puff's") Evangelical Lutheran Church situated at Puff's Corner (the intersection of Butler Pike and Susquehanna Avenue), the church began as a Sunday school meeting on January 29, 1907, at the home of John C. Bergey and his wife. It was organized in 1908 with 28 charter members, who met at the Opera House until the church construction was completed. (Collection of Ross Gordon Gerhart III, c. 1913.)

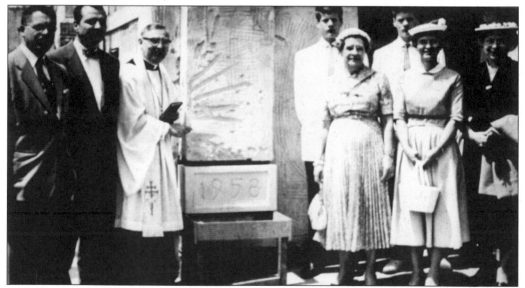

Attending the cornerstone-laying ceremony for the narthex addition of St. John's Evangelical Lutheran Church are the Reverend Paul R. Wertman (third from the left) and some members of the congregation. The church was built in 1912–1913 of cut stone and terra-cotta tiling with Century Asbestos shingle roofing. Seating about 250, St. John's was consecrated on March 2, 1913. The cornerstone was laid on June 8, 1912. (Collection of Ross Gordon Gerhart III, May 18, 1958.)

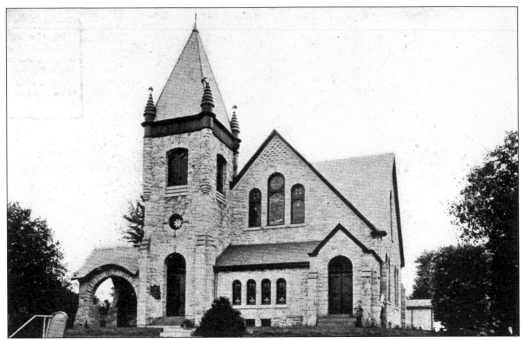

No one knows for certain when the First Presbyterian Church of Ambler was actually founded. Members initially met in 1886 in Edmund Plumley's Hall on the northeast corner of Main and Race Streets, but the church charter dates to 1893. After the sale of the Plumley property and then a devastating fire at Buchanan Hall (where the congregation next met), Charles Shoemaker allowed the congregation to set up a tent on his property on the southwest corner of Butler and Mattison Avenues, where the current church is located. (Courtesy of Wissahickon Valley Historical Society, c. 1907.)

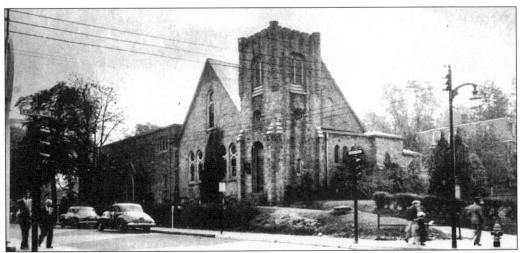

The First Presbyterian Church of Ambler underwent an extensive $35,000 facelift in 1935 that resulted in the squaring off of the tower, the covering up of the porte-cochere (the entrance gate to the left of the tower), and the adding of state-of-the-art amenities within the church. (Courtesy of Wissahickon Valley Historical Society, c. 1940.)

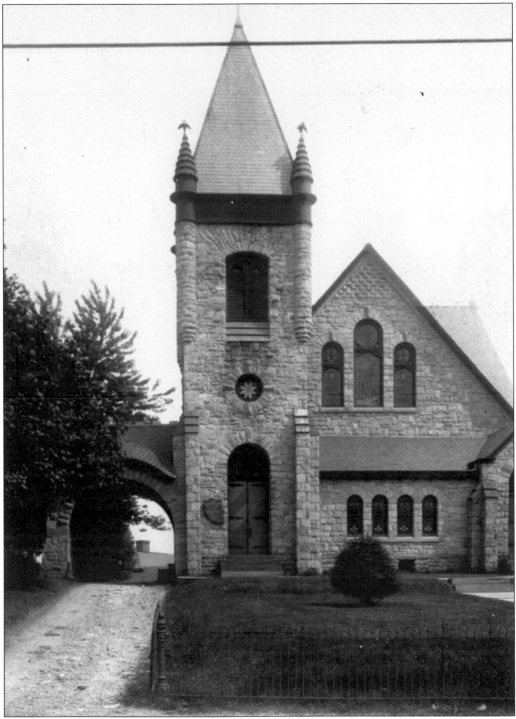

Here is a closeup view of the tower and porte-cochere to the left of the tower, where passengers in carriages and, later, automobiles could enter the First Presbyterian Church of Ambler. It remained this way until the extensive expansion and renovations of 1935. (Courtesy of Wissahickon Valley Historical Society, *c.* 1908.)

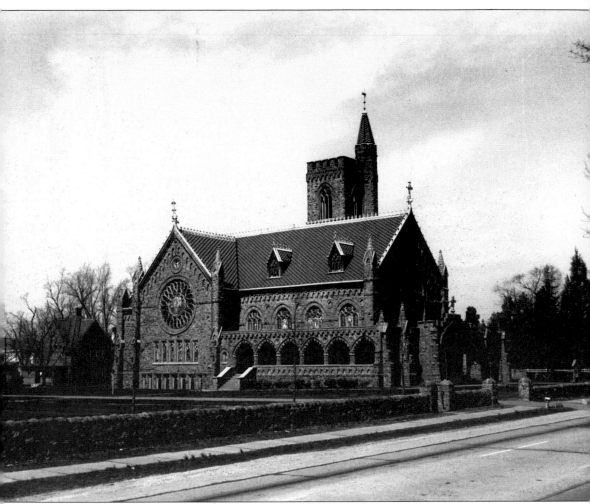

Serenity was the order of the day when this photograph was taken of Trinity Memorial Episcopal Church, located on three acres at the intersection of Bethlehem Pike and Highland Avenue across the road from the Mattisons' Lindenwold estate. The cornerstone, containing a copy of the *Ambler Gazette*, was laid on September 29, 1898. Designed for Richard V. Mattison by Samuel Franklin and built at a final cost of $150,000, it was acclaimed for its fine illuminated stained-glass windows. When the grand Gothic church was consumed by a devastating electrical fire on June 16, 1986, one man quoted in the *Gazette* said, "It was like looking into the gates of hell." Although the damage was in the millions, the congregation saw to it that Trinity would be restored in all of its former glory. The new cornerstone was laid in 1989. (Courtesy of Trinity Memorial Episcopal Church, *c.* 1910–1920.)

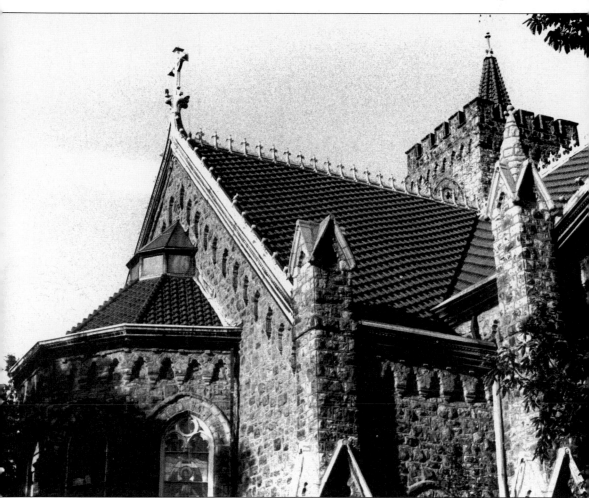

This is a detail of the roof and tower of Trinity Memorial Episcopal Church. Built by Richard V. Mattison in 1898 in memory of his deceased four-year-old daughter Esther Victoria Mattison, the church was subsidized by Mattison for years, and it was the church where he himself worshiped. The ceiling was 64 feet high. During the fire of 1986, the clay tile roof collapsed, leaving only a shell of stone walls. The stained-glass windows, created by J & R Lamb Studios, were considered among the most beautiful in the country. The church was rebuilt between 1986 and 1989 without the tower. (Courtesy of Trinity Memorial Episcopal Church, c. 1910–1920.)

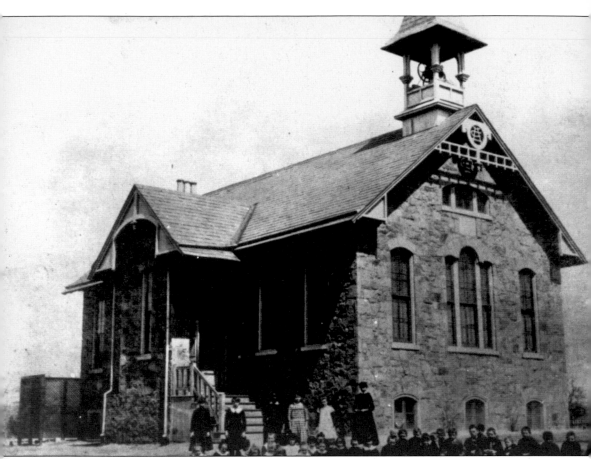

Ambler's oldest school, situated at Forest Avenue and Spring Garden, was an outgrowth of the Ambler Independent School District. It was established in 1881 in a more central location to reduce the inconvenience of travel for the school's 35 students, who came from Lower Gwynedd, Whitpain, Whitemarsh, and Upper Dublin Townships. It was a one-room, one-story structure surrounded by an iron fence. With some structural additions, it continued to serve the region's students well until it was destroyed by fire on February 20, 1926. A senior citizens' center is now located at the site. (Courtesy of Wissahickon Valley Historical Society, c. the late 1890s.)

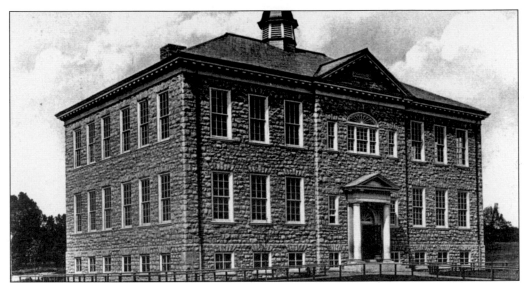

The Upper Dublin High School, also called the Matthias Sheeleigh School, was built for the children of employees of the Keasbey & Mattison Company. Located at the corner of Douglass and Argyle Avenues, its cornerstone was laid in 1906. It was demolished in 1961. (Courtesy of Wissahickon Valley Historical Society, c. 1907.)

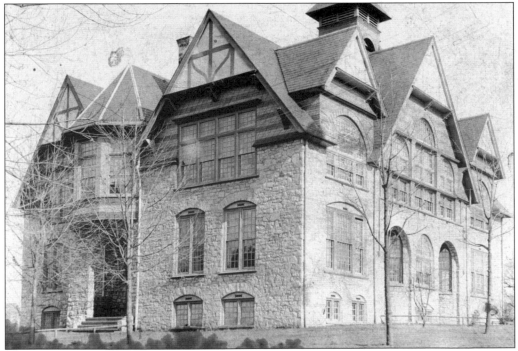

Here is a view of Forest Avenue School as it appeared after the renovations and expansion were completed in the late 1920s. At the time, the second floor and an entirely new wing were added. Although the legislature of the commonwealth passed a bill in 1911 to dissolve the independent school districts throughout the state, Forest Avenue School continued to serve the region's students until the fire of 1926. (Collection of Ross Gordon Gerhart III, c. late 1920s.)

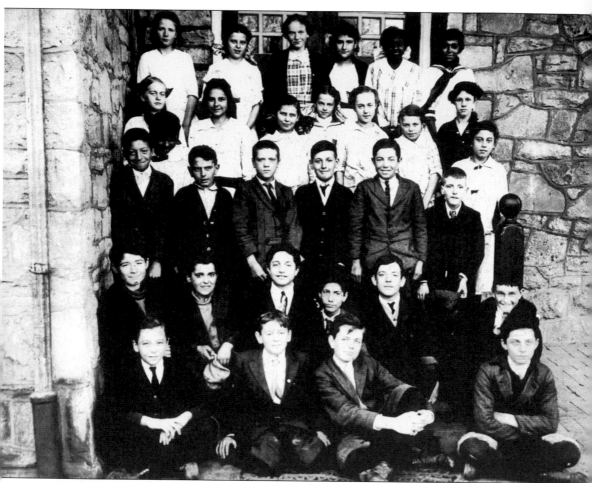

These bright young faces belong to students at the Mattison Avenue School. The school was built in 1903 with stone from Richard V. Mattison's quarry on Highland Avenue. It was demolished in 1967, one year after the new Mattison Avenue School had opened. (Courtesy of Wissahickon Valley Historical Society, *c.* 1912.)

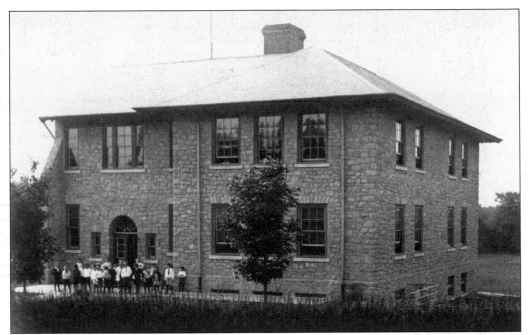

This full-sized view shows the Mattison Avenue School, with students and teachers out front. The school was located on Mattison Avenue at the junction of Ridge Avenue and Poplar Street. (Courtesy of Wissahickon Valley Historical Society, *c.* 1904.)

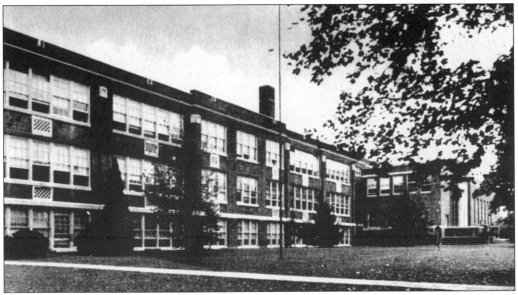

Ambler (Junior and Senior) High School, located at Tennis Avenue and Hendricks Street, was constructed over the course of three separate time frames. The first section (left) was completed in 1922. The second section (right), built partly with federal funds, was done in 1933. The final section was finished in 1957. The school closed in 1973. After it was demolished in 1978, a housing development took its place. (Courtesy of Wissahickon Valley Historical Society, *c.* the late 1930s.)

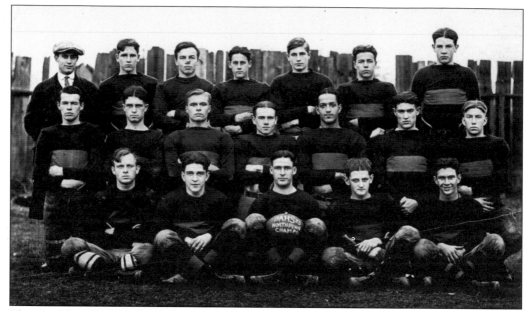

The Ambler High School football team did itself proud in 1923 when, after a hard-fought campaign, it became the North Penn champions. (Courtesy of Wissahickon Valley Historical Society.)

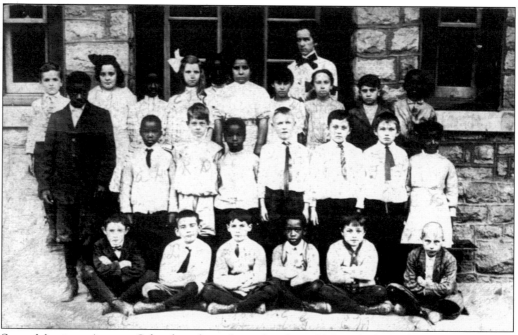

Some Mattison Avenue School students from the class of Miss Fleck (in back, with a ribbon around her neck) gather in front of the building for a group shot. The girl in the back row, second from the left, is LaVern Scheetz, the grandmother of Ross Gordon Gerhart III. (Collection of Ross Gordon Gerhart III, c. 1910–1920.)

Five

LANDMARKS
AND INSTITUTIONS

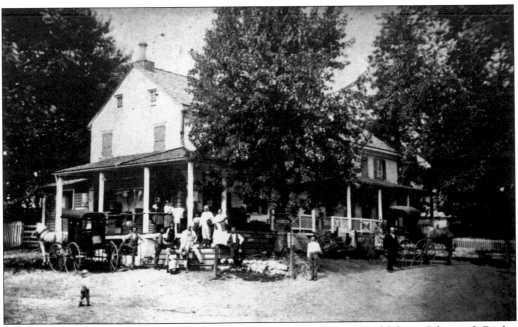

The bustling Rose Valley Store stands at the intersection of Bethlehem Pike and Butler Avenue, which was at the time the main crossroads of Ambler (then Wissahickon). Originally known as Andrew Gilkinson's Tavern, the building dates from the days of the American Revolution, when it was a magnet for all commerce coming through the village. (Courtesy of Wissahickon Valley Historical Society, *c.* 1870.)

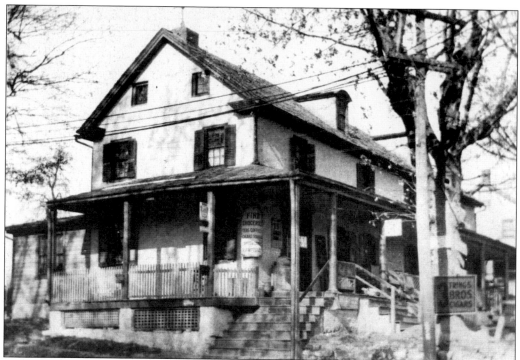

Still standing at the crossroads, the building that was the Rose Valley Store functions today as Costa's Delicatessen. Opened in 1950, minus the wraparound porch, Costa's is known for its fine sandwiches and even finer milk shakes. (Courtesy of Wissahickon Valley Historical Society, c. 1910–1920.)

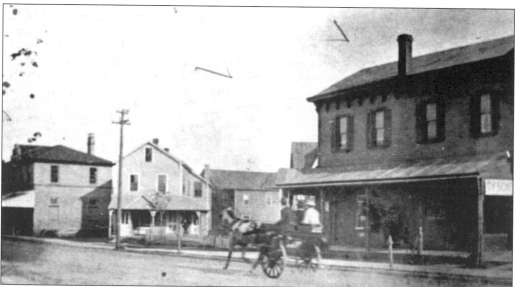

A horse pulling a cart with two passengers canters past Tyson's Store (right), which became King & Betz' Grocery, a mainstay in Ambler c. 1900. Located at 216 Lindenwold Avenue, the building now houses the Antique Drummer, the wood-laden sanctuary of cabinetmaker, horologist, and furniture-restorer Terry Addison. (Photograph by William S. Acuff, courtesy of Wissahickon Valley Historical Society, 1898.)

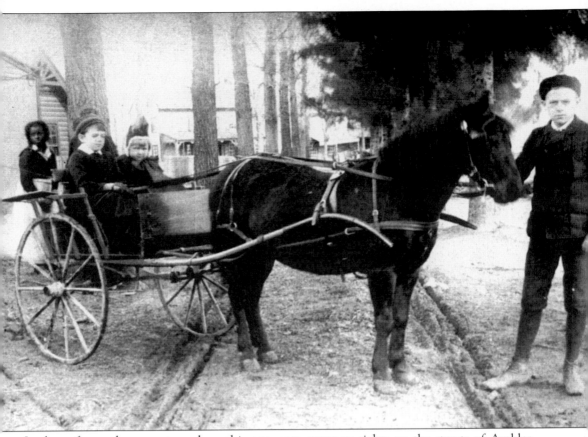

In days of yore, horse carts such as this one were common sights on the streets of Ambler. Holding the reins for two of his siblings is Alexander Knight, the son of George K. Knight, one of Ambler's leading citizens. Riding in the cart are sister Cordelia and brother Harold Grove Knight. Behind the cart is the children's nursemaid, Lettie Carr. George K. Knight, a Philadelphian attracted by Ambler's growth potential along the North Penn Railroad line, bought a substantial tract of land in the area and soon paved the way for Ambler's first bank, savings and loan association, and other businesses. A well-respected gentleman, son Alexander Knight was in the carpet business and was also bank director. Cordelia and sister Sarah Knight became directors of the Sunnyside School founded by their sister Elizabeth Knight. Judge Harold Grove Knight served for 30 years on the Montgomery County bench, and as president judge for more than 20 of them. (Courtesy of Wissahickon Valley Historical Society, c. 1890.)

Here is a view of the barn on the Knight family farm. The initial tract of land purchased by George K. Knight was part of the Corson estate, situated on both sides of the railroad tracks and extending up to the station. Knight later acquired more land along Butler Avenue. (Courtesy of Wissahickon Valley Historical Society, c. 1910–1915.)

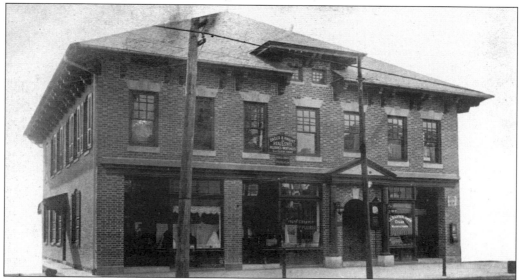

The Knight Building, a suite of professional offices, was located on the corner of Butler Avenue and Main Street. From here, George K. Knight could direct his many enterprises, which included banking. His children were also involved with the community, introducing the town's first school and several businesses and becoming active in various civic institutions. The Timoney law firm occupied this building for many years before moving to Fort Washington. (Courtesy of Wissahickon Valley Historical Society, c. 1906.)

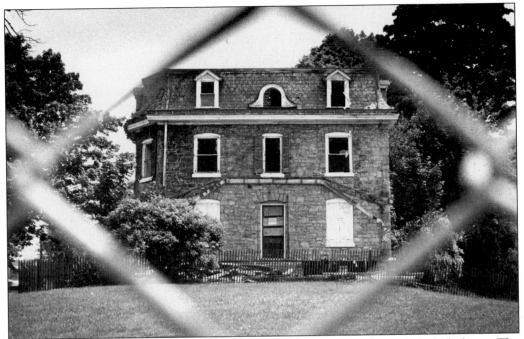

Time was not kind to the old Knight mansion, seen here through a chain-link fence. The Homestead Apartments eventually replaced the Knight mansion at this site. (Photograph by Willard Krieble, courtesy of Wissahickon Valley Historical Society, *c.* 1976.)

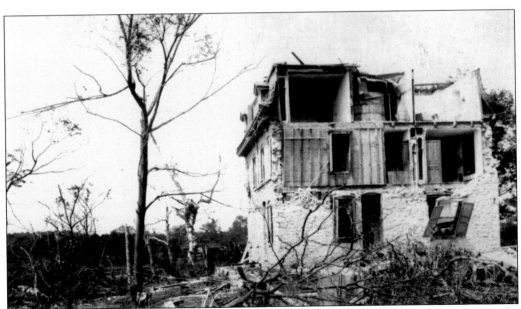

Hit hard by a tornado that ripped through Montgomery County in the 1880s, the Knight mansion on South Main Street is currently the site of Knight Park. (Courtesy of Wissahickon Valley Historical Society, *c.* the 1980s.)

The old ash tree on the Shoemaker property was 230 years old when this picture was taken. It was felled during a severe storm in the 1940s. (Courtesy of Wissahickon Valley Historical Society, 1936.)

The grounds where the old ash tree lived for more than 200 years are now a parking lot behind Cavalier Drive just around the corner from Ambler's Act II Playhouse, which opened in 1999. Located at 56 East Butler Avenue, it is Montgomery County's first professional theater. (Courtesy of Wissahickon Valley Historical Society, 1936.)

This distinguished-looking man is
Jesse F. Davis, the funeral director of the
Davis Funeral Home, one of the oldest in
the area. (Collection of Ross Gordon
Gerhart III, c. the late 1930s.)

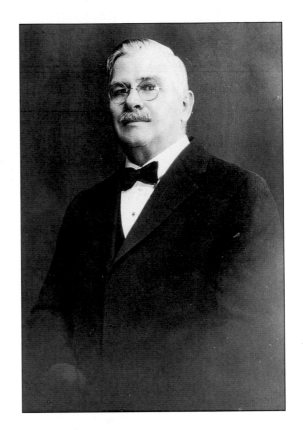

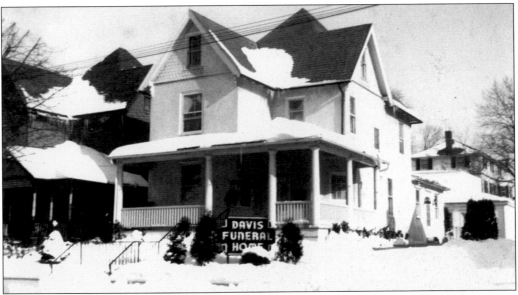

Situated at 131 North Main Street at Belmont Avenue, the Davis Funeral Home served the
community for many years. It was founded in 1810 and was originally located in Fort
Washington. The Davis family brought their funeral home to Ambler in the late 1880s or early
1890s. The business later became the Hassinger Funeral Home. (Collection of Ross Gordon
Gerhart III, 1961.)

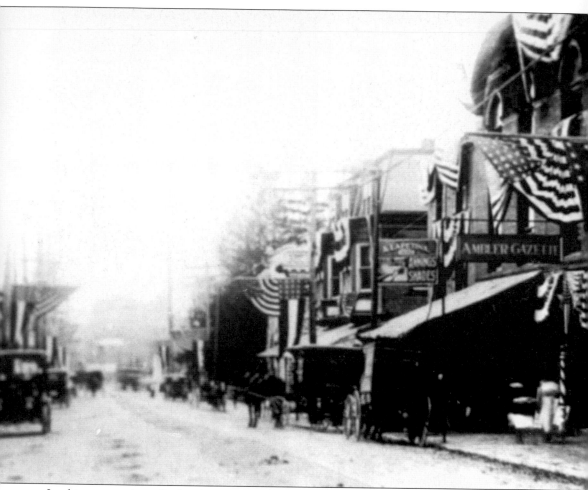

Looking west along Butler Avenue, Ambler's main thoroughfare, one can only imagine what the road looked like from 1853 to 1890, when it was a toll road with two tollgates, one at Broad Axe and the other near Three Tuns, farther east. The road, originally laid out in 1712 and used by the Quakers to journey to their meetinghouse in Plymouth Meeting, was named Butler because it ultimately led to Butler's Mill in Chalfont, Bucks County. (Courtesy of Wissahickon Valley Public Library, c. the 1900s.)

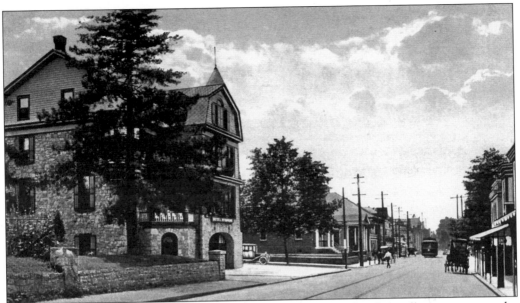

This peaceful view of Butler Avenue shows the Wyndham Hotel and its tall spruce tree on the left, and the curious juxtaposition of 19th- and 20th-century conveyances, including horse-drawn carriages, an automobile, and a trolley car. (Courtesy of Wissahickon Valley Historical Society, c. 1916.)

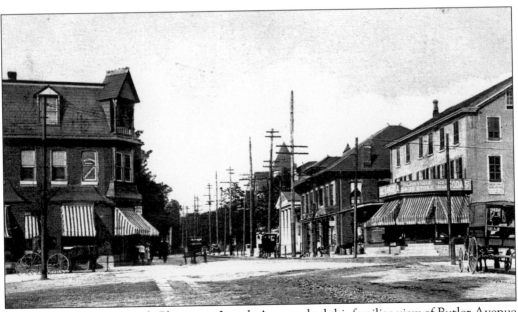

The owner of the Sunnyside Pharmacy, Joseph Angeny, had this familiar view of Butler Avenue color-lithographed in Germany. Postcard views of picturesque towns, villages, and country scenes were all the rage just after 1900. (Collection of Ross Gordon Gerhart III, c. 1905.)

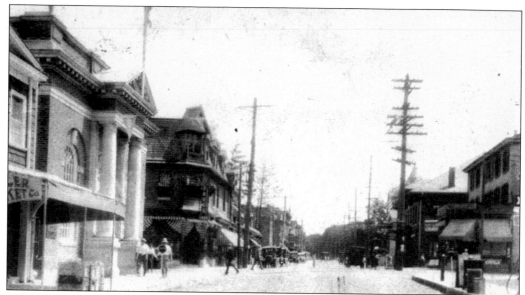

This view of Ambler's Butler Avenue business district shows the ascendancy of the automobile. No horse-drawn carriages are in view, and a curbside gasoline pump can be seen (lower right). (Courtesy of Wissahickon Valley Historical Society, 1921.)

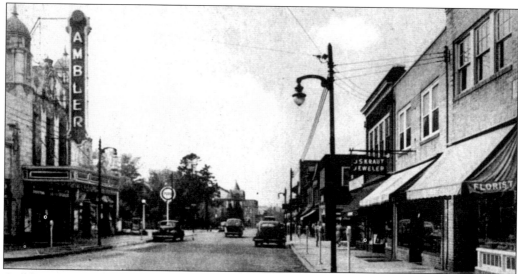

Ambler's main thoroughfare is shown on what appears to be a quiet Sunday afternoon. At the far left is the 1,200-seat Ambler Theatre, at 108 East Butler Avenue. Built in 1928 by the Harrison Brothers when Hollywood's Golden Age was born, the cinema was, and still is, a luxurious architectural jewel. Decay and disrepair inevitably took their toll, and the theater closed in 1997. Renovated and fully restored, it reopened in February 2002. (Courtesy of Wissahickon Valley Historical Society, 1940.)

It is hard to believe that this is the same Butler Avenue that once served the community as a turnpike, a toll road that eventually had three tollgates, including one where it intersected Main Street. In 1890, two years after Ambler was incorporated as a borough, the final tollgate came down. There were no more tolls until the parking meters came along later on Butler Avenue and in parking lots along the side streets. (Courtesy of Wissahickon Valley Historical Society, 1960.)

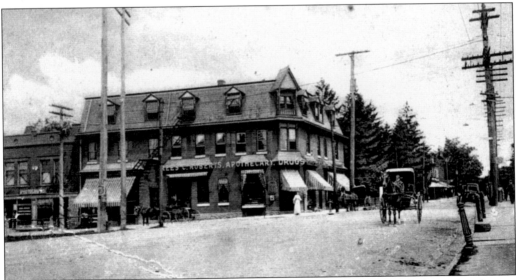

At the northeast corner of Butler Avenue and Main Street, the Rees C. Roberts Apothecary was a familiar landmark in Ambler from 1894 to 1921, when it was replaced by Brenneman and Brady's Drug Store. With its charming if unsettling juxtaposition of horse-drawn conveyances and the horsepower of the automobile, this photograph also shows the intermingling of the late 19th and early 20th centuries. (Courtesy of Wissahickon Valley Historical Society, c. 1906.)

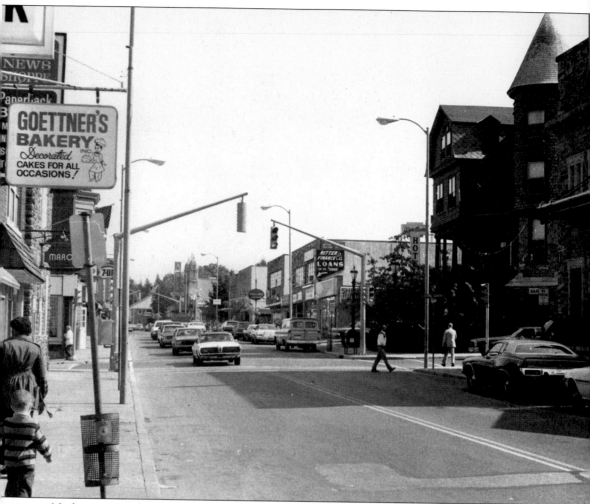

No longer a road made of crushed stone and dirt, Butler Avenue, with its bank, savings and loan association, bakery, news shop, and parking lots, is every inch the thriving business center of the vibrant borough of Ambler. (Courtesy of Wissahickon Valley Public Library, 1977.)

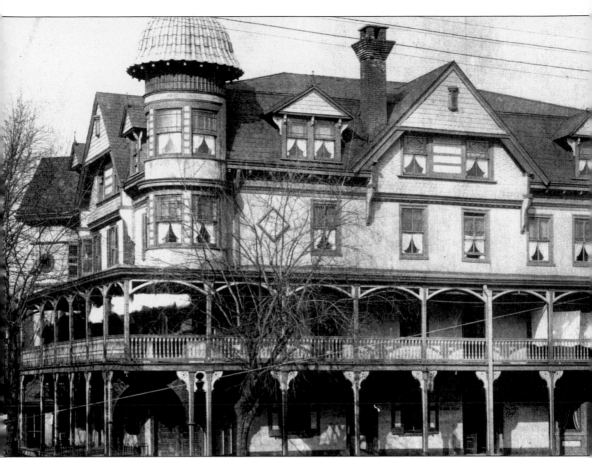

The Hotel Ambler, first called Blackburn's Hotel, was built next to the railroad station in 1867. With its turrets, dormers, and wraparound porches, this Victorian marvel attracted the summer tourists who flocked to the area to attend the Montgomery County Agricultural Fairs. The week-long fairs, with their exhibits of animals, agricultural techniques and tips, pie-eating contests, and all manner of live musical entertainment and fresh food, were staples in Ambler from 1872 to 1877. After nearly 80 years of serving guests from all over the region, the hotel met an untimely end when fire consumed it on Christmas Eve 1946. (Courtesy of Wissahickon Valley Historical Society.)

Here is a closeup view of a tower and porch of the Wyndham Hotel, a staple in the community for 110 years. It is expected to become a restaurant again in the near future. (Courtesy of Wissahickon Valley Historical Society, *c.* 1908.)

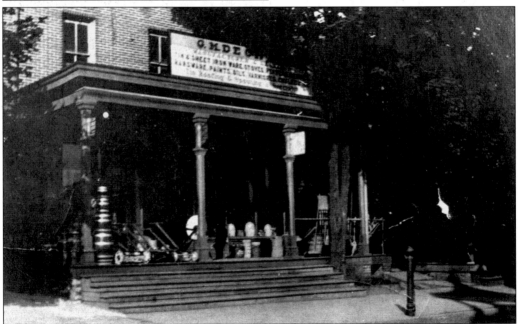

G.M. Deck & Sons Hardware, located at 121 North Main Street, has been providing the community with ironware, stoves, paints, varnishes, and hardware of every kind since it first opened its doors in 1908. The family-owned-and-operated business has watched and serviced the steady growth of Ambler for nearly a century. (Courtesy of the Deck family, *c.* 1910.)

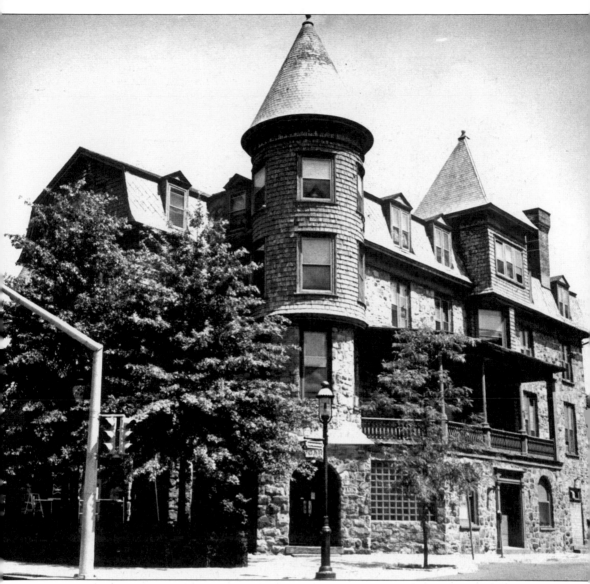

The Wyndham Hotel, built in 1893 for the sum of $35,000, is a Queen Anne Victorian that once boasted 45 rooms, including 28 bedrooms. Before the advent of the automobile, the hotel's extensive stables in the rear, capable of accommodating 40 horses, made the Wyndham an attractive stopping point for travelers. (Courtesy of Wissahickon Valley Historical Society.)

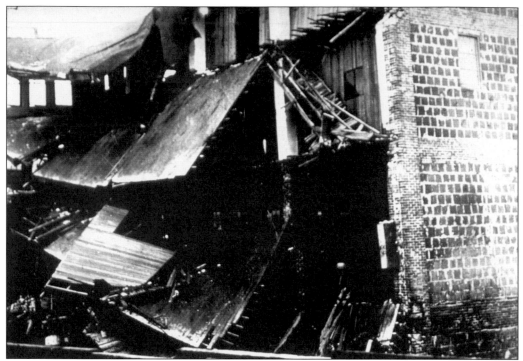

After a fire in the early 1920s, this is all that remained of the Wyndham Hotel's vaunted stables. Eventually, houses were built behind the hotel. At the time of the fire, Charles Weikel Gerhart Sr. was renting the stables for his moving, storage, and livery business. (Collection of Ross Gordon Gerhart III, c. 1921.)

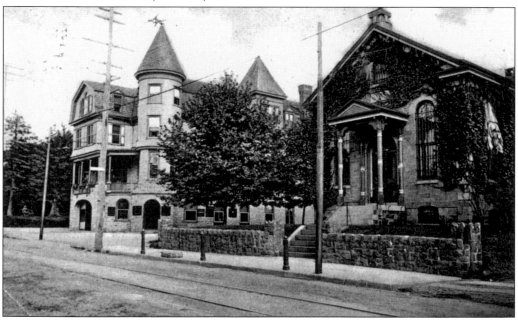

Seen here along Butler Avenue on opposite sides of Spring Garden Street are the Wyndham Hotel (left) and the First National Bank of Ambler. Conceived by town patriarch George K. Knight, the bank was built in 1884. (Courtesy of Wissahickon Valley Historical Society, c. 1906.)

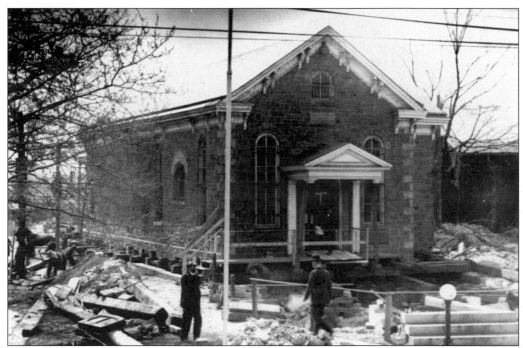

Few Ambler residents who were out and about in the early 1920s could forget this scene, as workmen moved the First National Bank on rollers to the rear of its original position at Butler Avenue and Spring Garden Street. The Girard Trust Corn Exchange Bank and other businesses eventually replaced the bank. (Courtesy of Wissahickon Valley Historical Society, 1923.)

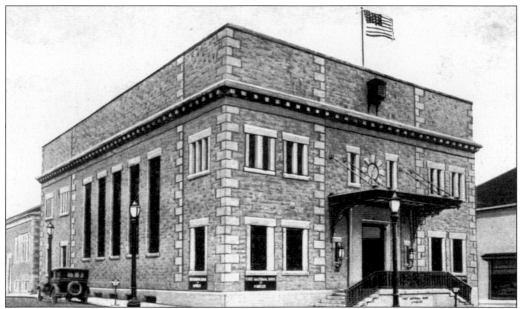

With street lamps as sentinels, a newfangled automobile parked outside, and a flag flying above the entrance, here is the First National Bank as it appeared in the late 1920s. This building replaced the bank moved to the rear of this site earlier that decade. (Courtesy of Wissahickon Valley Historical Society, c. 1930.)

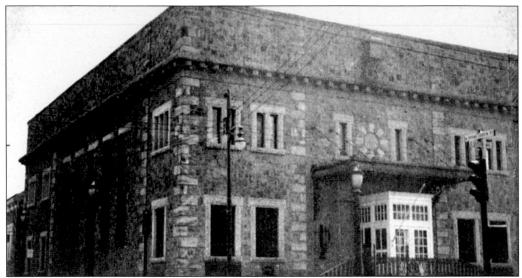

The First National Bank of Ambler was completely rebuilt in 1923 in its original location. Legal offices now occupy the building. (Courtesy of Wissahickon Valley Historical Society, 1926.)

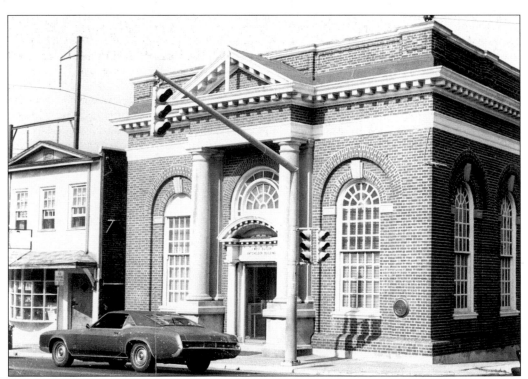

The Ambler Trust Company, a solid brick building with Doric columns flanking the main entrance, is situated at the corner of Butler Avenue and Main Street. Constructed in 1916, the building still stands. Today, it houses Palladio, a new shop that offers accessories for the home and garden. (Courtesy of Wissahickon Valley Public Library, 1977.)

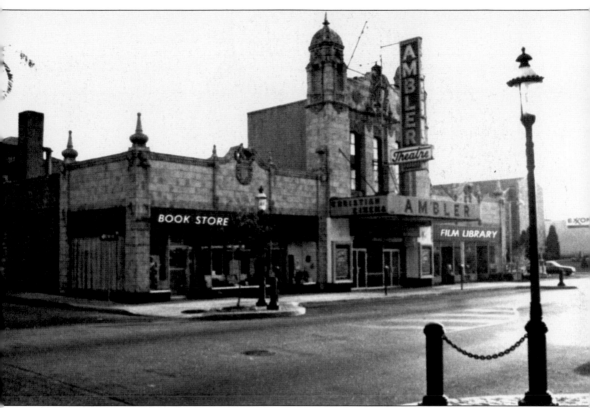

A landmark at 108 East Butler Avenue since 1928, the Ambler Theatre was a luxurious Hollywood movie house for many decades. After some decline, it was sold in the 1970s. Purchased by the Reverend Harry Bristow, it served as the borough's Christian cinema from the 1970s until its closing in 1997. The Christian Book Store adjacent to the cinema is now Jimmy Rubino's Ralph's of South Philadelphia, a popular restaurant that, along with the reopened Ambler Theater, has been a linchpin in the revitalization of Ambler. (Collection of Ross Gordon Gerhart III, *c.* the 1980s.)

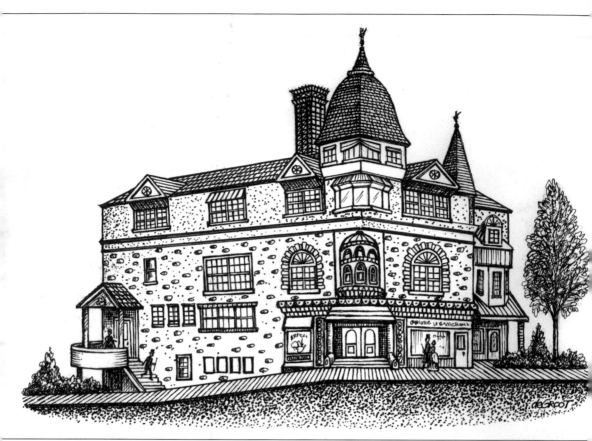

In 1999, the Wissahickon Valley Historical Society commissioned artist Lee deGroot to draw this original artwork of Buchanan Hall. Built by the Buchanan brothers on the corner of Butler Avenue and Main Street in 1887, this magnificent late-Victorian structure housed not only offices, retail stores, and rooms where no fewer than five local lodges could meet but also an opera house and the Union Library. On February 9, 1890, in Ambler's worst fire to that point, the grand hall burned to the ground, along with a number of buildings nearby. (Lee deGroot, commissioned by Wissahickon Valley Historical Society, 1999.)

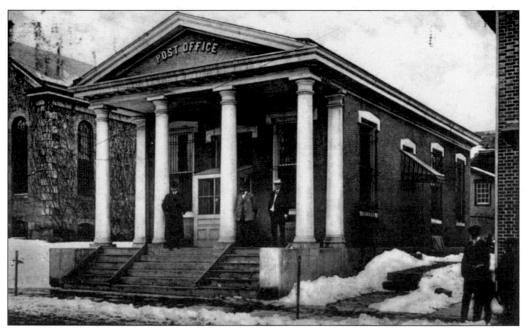

For a time in the first quarter of the 20th century, the Ambler Post Office was housed in this building. Erected in 1898 on Butler Avenue, it was one of many homes the post office had had since it was founded in 1826. The earliest postmasters, including Isaac Thomas (the first), operated it from their own homes. Among the most notable postmasters were Elizabeth Knight, who also opened Ambler's first school, and Mary Ambler's son Evan Ambler. (Courtesy of collection of Ross Gordon Gerhart III, *c.* 1906.)

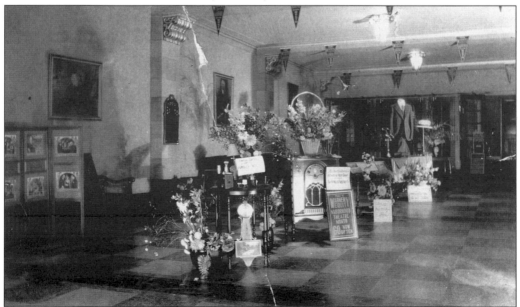

Pictured here is the festive lobby of the Ambler Theatre during a special promotion held a year or two after the cinema was built at 108 East Butler Avenue. The Ambler became a cinema showing Christian films in the late 1970s and early 1980s. (Courtesy of Wissahickon Valley Historical Society, *c.* 1930.)

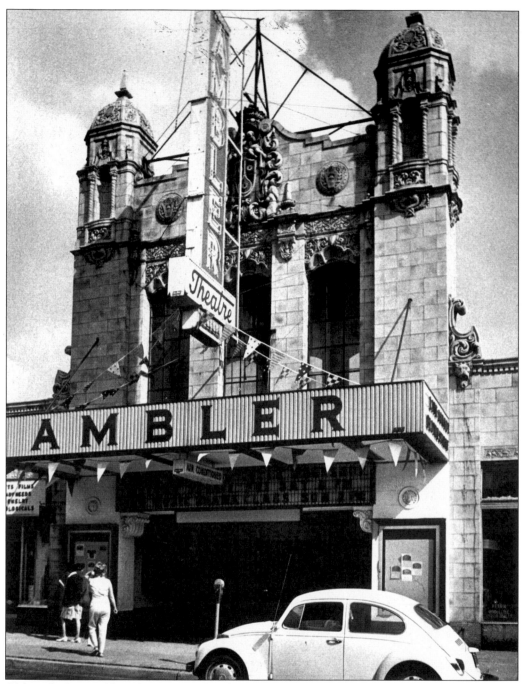

Although the Ambler Theatre was closed for several years, it reopened with great expectations and fanfare in the winter of 2003. Showing art films on three screens and called the Ambler Theater, the cinema has been a major force in the revitalization of downtown Ambler. Next door to the theater at the corner of Butler Avenue and York Street is another major player in the revitalization effort: Jimmy Rubino's Ralph's of South Philadelphia restaurant, an offshoot of the family-owned-and-operated Ralph's of South Philadelphia, an institution in the Italian Market for more than 100 years. (Courtesy of Wissahickon Valley Historical Society, 1975.)

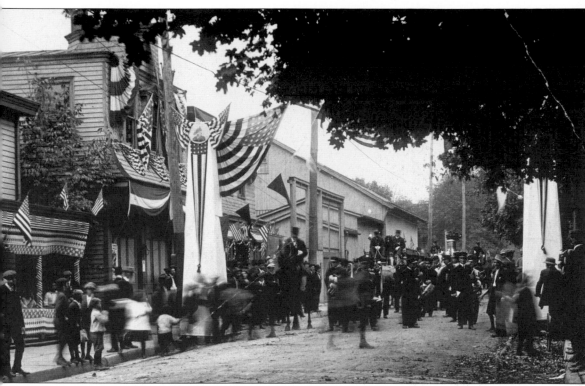

Amblerites love a good parade. This one, making its way down North Main Street in front of the original location of the Wissahickon Fire Company, was probably the town's annual Memorial Day parade. The sheds in the center were those of the Craft Lumber Yard, now the site of Ambler Manor. (Courtesy of Wissahickon Valley Historical Society, 1913.)

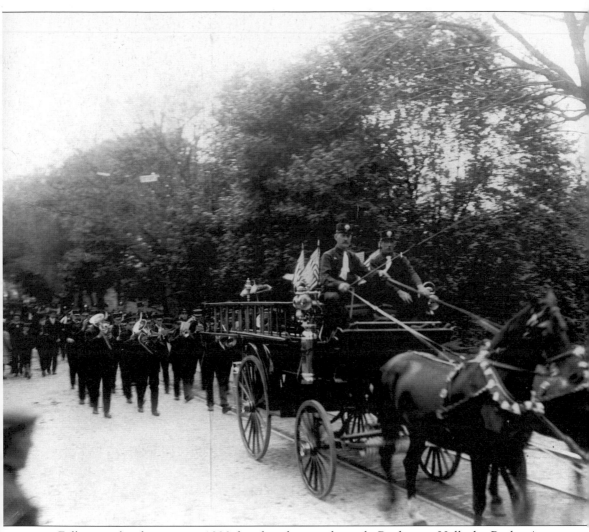

Following the devastating 1890 fire that destroyed stately Buchanan Hall, the Butler Avenue tollgate, and several sheds belonging to a hotel nearby, it was clear that Ambler's fire-prevention system was totally inadequate for the task at hand. The Keasbey & Mattison Company had volunteered to provide water from its own pumps to help put out local fires. It was not enough. Thus, a charter giving birth to the Wissahickon Fire Company took effect on April 6, 1891. The fire company rented its first building at 9 North Main Street. Every year thereafter, the fire company proved to be the class of every Ambler parade, including this one, featuring its new horse-drawn ladder wagon. (Courtesy of Wissahickon Fire Company, 1891.)

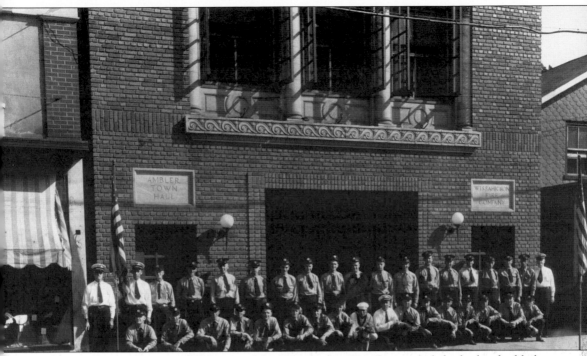

Lined up in front of the second location of the Wissahickon Fire Company (which also doubled as Ambler Town Hall) on Butler Avenue are firefighters. From left to right, they are identified as follows: (front row) Graham, Kitchen, Sheppard Jr., Fluck, Stevens, Streeper, Moore, McCall, Porter, mascot Gyp, Chief Thomas, Fleck Sr., Malsberry, Bishop, Styr, Stillwagon, Lawrence, and Murray; (back row) Lentz, Bowers, Brown, Livezey, Scott, Groff, H. Tanney, Tomilson, Garritt, Douglass, Hinkel, Robbins, Feldje, J. Fertsch, R. Fertsch, Hayden, Wacker, C. Tanney, and President Duecher. (Courtesy of Wissahickon Fire Company, *c.* the early 1930s.)

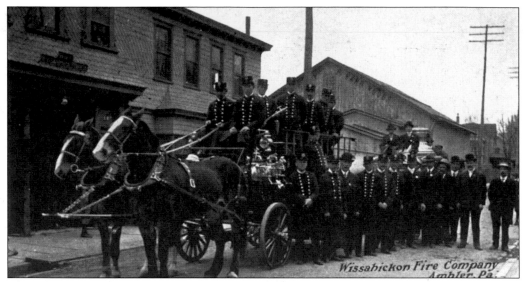

The volunteer firefighters of the Wissahickon Fire Company proudly display their new uniforms and their horse-drawn fire wagon in front of the original firehouse on North Main Street. (Courtesy of Wissahickon Valley Historical Society, c. 1908.)

Even the best efforts of the Wissahickon Fire Company could not save the Howard Johnson's restaurant in the early 1950s. (Courtesy of Wissahickon Valley Historical Society, c. the 1950s.)

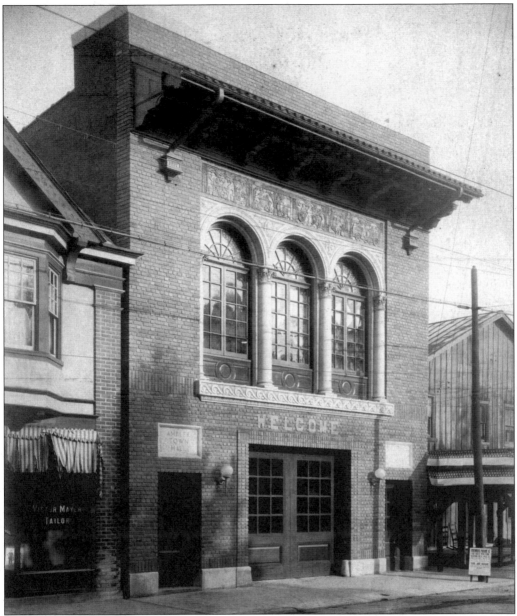

The Wissahickon Fire Company and Town Hall was designed by architect Watson K. Phillips and dedicated on November 3, 1917. The fire company remained at this Butler Avenue location until it outgrew those quarters and moved into the current firehouse on Race Street on November 3, 1958. The frieze above the triple-arched windows, composed of Moravian tiles handmade in 1917 at the Moravian Tile Works in Doylestown, was saved when the building was demolished on St. Valentine's Day in 1962. Depicting scenes of the early days of volunteer firefighting, including a horse-drawn steam pump, the tiles were removed, reassembled, and mounted at Lapetina's Furniture Store, later Regan's Shoe Store, both now closed. (Courtesy of Wissahickon Fire Company, 1918.)

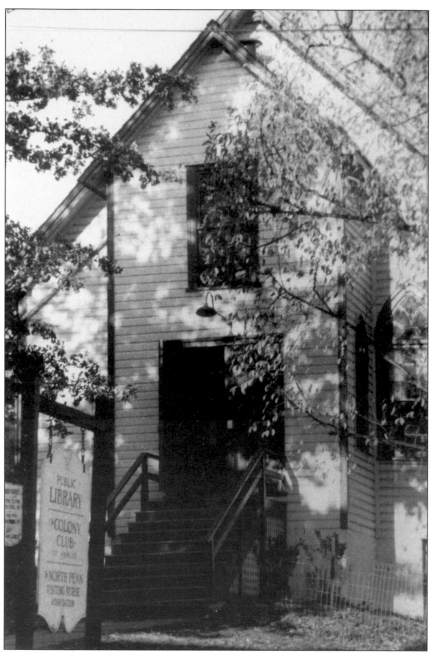

Organized in 1912, the Colony Club (and the Junior Colony Club) of Ambler is still located at the corner of Ridge Avenue and Race Street in a building that was at various times the home of the First Methodist Church of Ambler, the North Penn Community Center, and the Ambler Public Library. The Colony Club is one of the oldest women's groups in the region. Known for its benevolent works, it was founded one summer afternoon in 1912 at a whist party given by Hannah Rodgers of Trinity Place for some of her friends. When Mrs. Alexander Marcy, the mother of the hostess, spoke of the cultural and civic benefits of such a group, the group responded with enthusiasm and immediately elected their first president, Mrs. Thomas Atkinson. (Courtesy of Wissahickon Valley Public Library.)

Six

THE FACES OF AMBLER

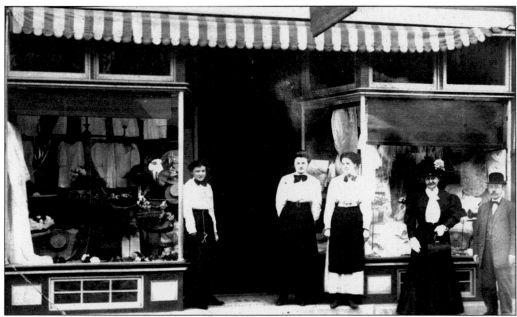

At the beginning of the 20th century, five residents of Ambler stand in front of Mrs. Heiss's dry goods store, a haberdashery offering clothing for both women and men. From left to right are Lizzie Cook, Mary Hauck, Lizzie Coleman, Carrie Heiss, and Walter Heiss. The store on the left is now an antiques shop and gallery called Pink Clover, and the store on the right houses a stationery shop called Dialogue. (Collection of Ross Gordon Gerhart III, *c.* 1900.)

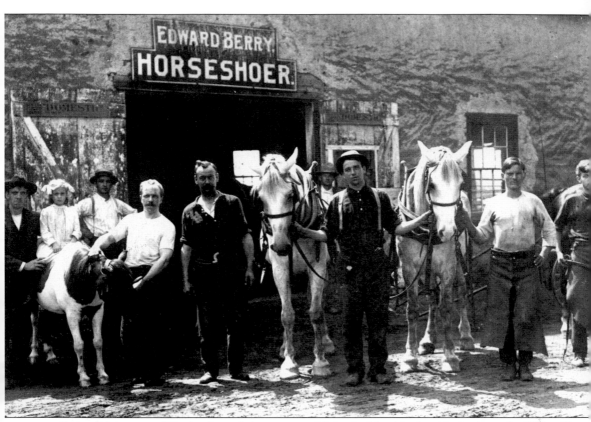

Even as the automobile slowly made its presence felt in Ambler, blacksmiths in the early 1900s still made a fairly good living. Pictured are some local smithies and their customers in front of Edward Berry's Horseshoer (and blacksmith shop). (Collection of Ross Gordon Gerhart III, *c.* 1910.)

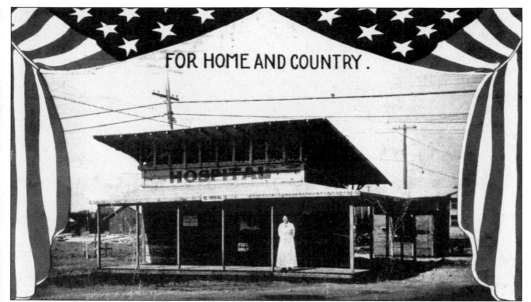

A woman stands before the entrance of an emergency hospital set up in Ambler in 1918 to care for victims of the flu epidemic that was sweeping the nation. (Courtesy of Wissahickon Valley Historical Society.)

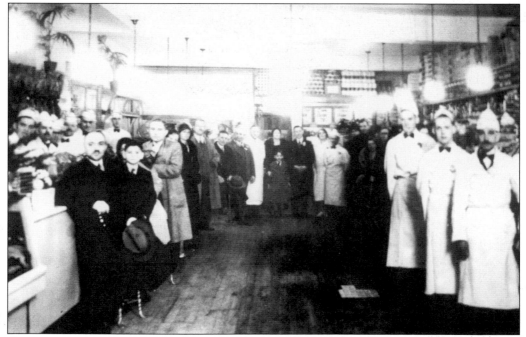

Customers and staff stand in a horseshoe pattern inside the American Store, a popular variation on the general store in Ambler in the first quarter of the 20th century. Located on East Butler Avenue, the American Store was actually divided into two sections. One offered fresh produce and the services of a butcher, George Linde, and the other offered canned goods and related products. (Collection of Ross Gordon Gerhart III, c. the 1920s.)

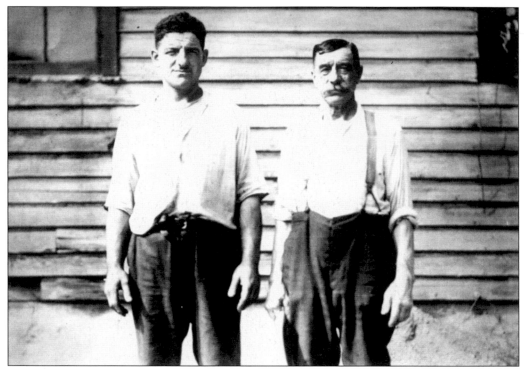

Ross Gordon Gerhart Sr. (left) and Charles Weikel Gerhart Sr. stand outside their warehouse at Park Avenue at Greenwood. (Collection of Ross Gordon Gerhart III, *c.* the 1930s.)

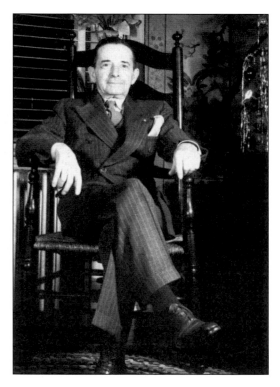

Former Ambler postmaster Oscar Stillwagon (October 31, 1875–October 14, 1952) seems to be enjoying the holiday season. A small Christmas tree sits upon a bureau (upper right). (Collection of Ross Gordon Gerhart III.)

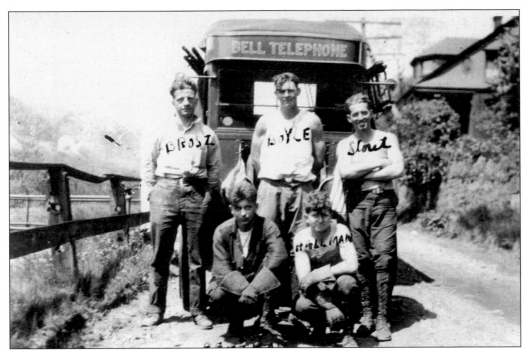

They might not be from Wichita, but these Bell Telephone linemen put in some long hours working on the new Ambler lines. (Collection of Ross Gordon Gerhart III, *c.* 1925–1935.)

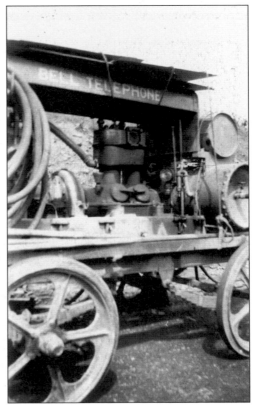

On their mobile, state-of-the-art supply cart, the Bell Telephone linemen have all the equipment they need to lay and repair phone lines. (Collection of Ross Gordon Gerhart III, *c.* 1930.)

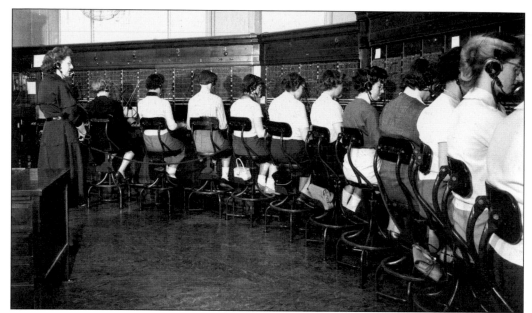

For those who think that privacy is all but gone in today's work spaces, with the flimsiest of partitions separating one cubicle from another, consider how difficult it must have been working at Ambler's Bell Telephone Exchange, where operators sat on high chairs only inches away from their coworkers, all taking calls at the same time. (Photograph by J.A. Armstrong, collection of Ross Gordon Gerhart III, *c.* the late 1940s.)

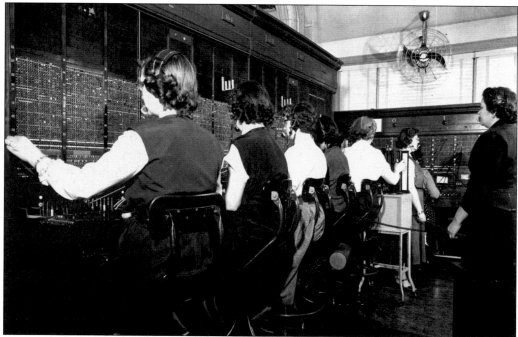

Here is a closer view of the telephone panels and the close working conditions at Ambler's Bell Telephone Exchange, located in the former Ambler Borough Hall at East Butler Avenue and North Spring Garden Street. (Photograph by J.A. Armstrong, collection of Ross Gordon Gerhart III, *c.* the late 1940s.)

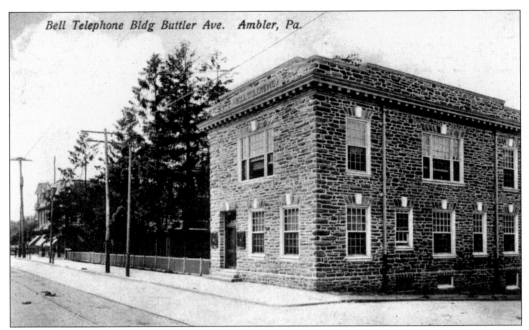

Bell Telephone Bldg Buttler Ave. Ambler, Pa.

The two-story Bell Telephone Exchange was located on Butler Avenue at Spring Garden Street, the site of the Ambler Borough Hall for many years. (Courtesy of Wissahickon Valley Historical Society, c. 1916.)

Four volunteer firefighters congregate around the new fire engine outside the Butler Avenue building of the Wissahickon Fire Company. The building was sold to Lapetina's Furniture Store in 1960. Ironically, during a frigid snowstorm on Valentine's Day 1962, a serious fire at the furniture company caused losses estimated at $200,000. (Courtesy of Wissahickon Valley Historical Society, c. the 1920s.)

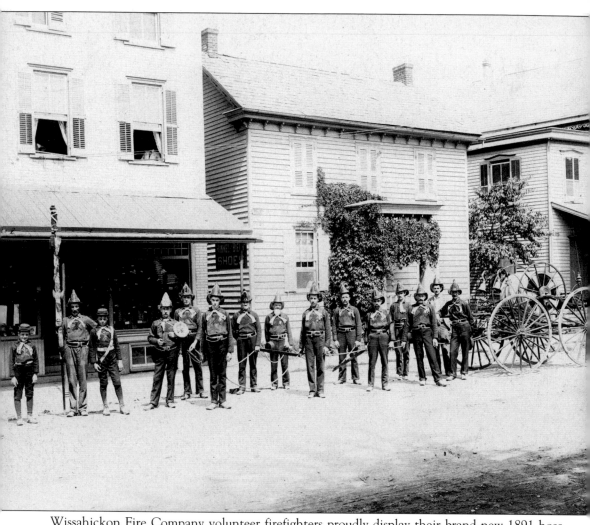

Wissahickon Fire Company volunteer firefighters proudly display their brand-new 1891 hose reel cart, which could be hand drawn or horse drawn. Purchased in June for $404, the cart carried 850 feet of hose. (Courtesy of Wissahickon Fire Company, 1891.)

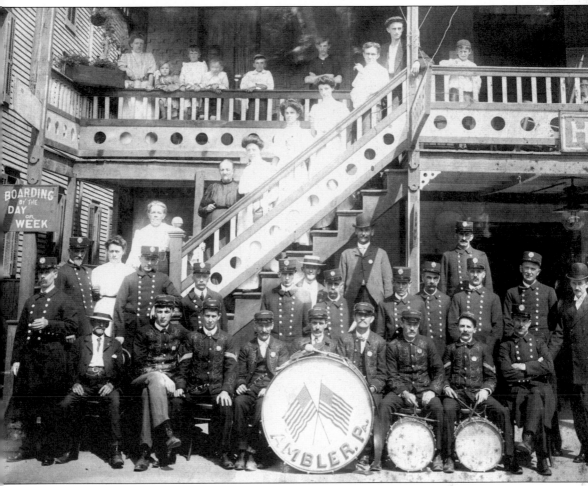

On September 9, 1906, several volunteers from the Wissahickon Valley Fire Company, accompanied by five members of the Ambler Fife and Drum Corps, made a day trip to Atlantic City, New Jersey. In appreciation for services rendered, the company paid for all expenses—except for one fireman, who reputedly had far too good a time and was fined $5 for conduct unbecoming of a member of the company. After this trip, a fund was set aside to help defray expenses for future outings. (Courtesy of Wissahickon Fire Company.)

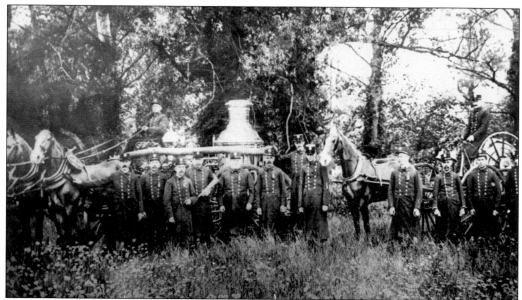

Members of the Wissahickon Fire Company rode their first steamer (an 1896 Silsby) and an 1891 hose reel cart across to the other side of the Wissahickon Bridge. The driver of the steamer (left) is Dick Ford, and the driver of the hose reel cart is Sam Stong. With them are, from left to right, Harry Crockett, Jim Stevens, Walter Heiss, Chief John McCool, Whitey McCool, Ed Clemens, Ben Meyers, Tin Van Horn, Tug Wilson, John Sins, ? Comely, and Tommy Thompson. (Photograph by Stephen Blodgett, courtesy of Wissahickon Fire Company, 1900.)

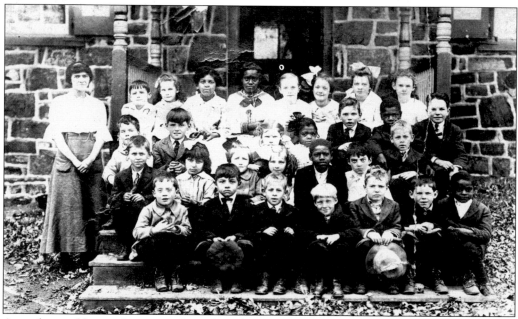

A teacher and her students pose for a class photograph on the steps of the Maple Grove School. (Collection of Ross Gordon Gerhart III, c. 1900–1910.)

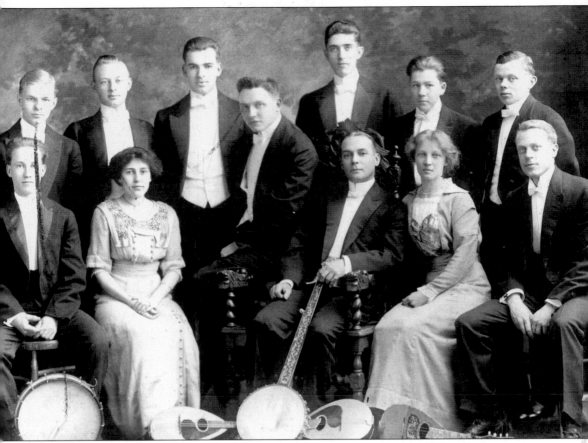

Ambler's churches were a source of cultural outreach, as well as spiritual uplift. A case in point is the Mandolin Society of Mount Pleasant Baptist Church. Among the identified members are Edward Sage and Linda Sage Redington (seated third and second from the right). (Collection of Ross Gordon Gerhart III, 1910–1920.)

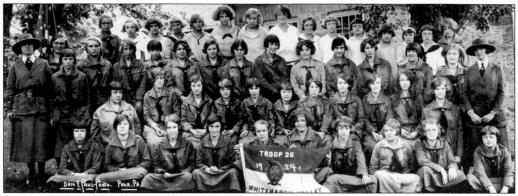

The Whitemarsh Valley Girl Scouts Troop 26, an Ambler institution for years, reveals some of the best and brightest faces Ambler has worn throughout its lengthy history. (Collection of Ross Gordon Gerhart III, 1924.)

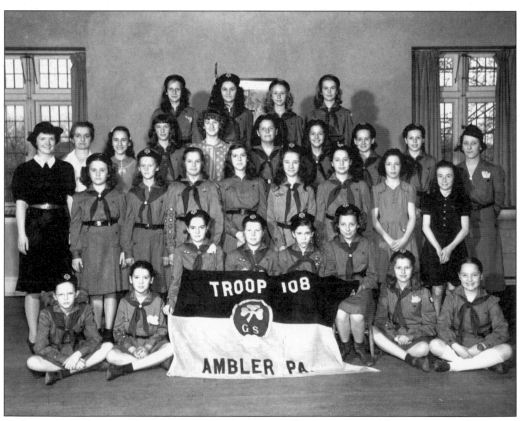

Fashions may change over time but not the sense of civic spirit and hearty camaraderie that makes up the typical Girl Scout troop. Pictured here during the middle of World War II is Ambler's Girl Scout Troop 108. (Courtesy of Wissahickon Valley Historical Society, 1943.)

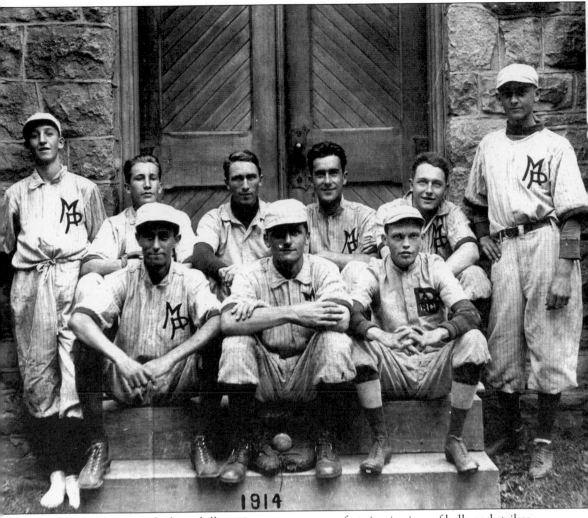

1914

Obviously eager to match their skills against any opponent for nine innings of balls and strikes, the Mount Pleasant Church baseball team pauses on the church steps before heading out to the baseball field. (Collection of Ross Gordon Gerhart III, 1914.)

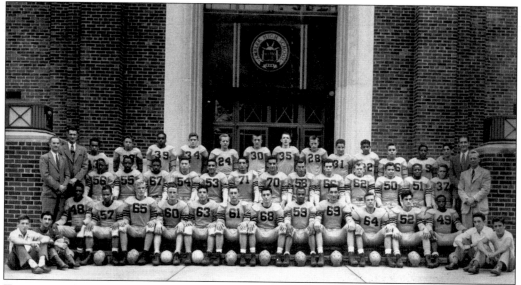

Team sports have always provided the youth of Ambler with opportunities to learn teamwork, to work off excess energy, and to enjoy the challenge of competition. Pictured in front of Ambler High School's new wing (built in 1938) just before the outbreak of World War II is the school's football team. (Courtesy of Wissahickon Valley Historical Society, *c.* 1941.)

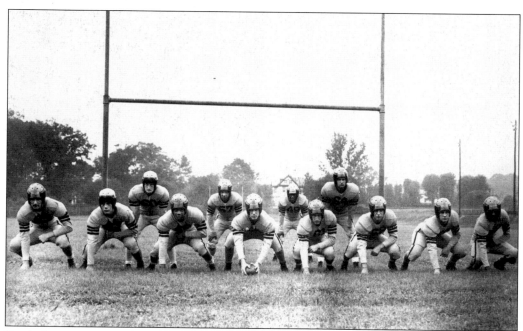

Ready for practice or a big game, Ambler High School's starting 11 (plus 1) takes to the field. (Courtesy of Wissahickon Valley Historical Society, *c.* 1941.)

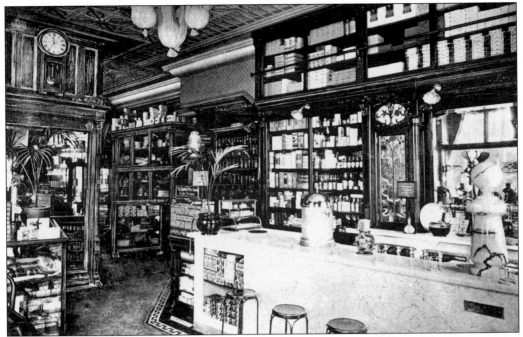

Under a stylish tin roof, the interior of the Rees C. Roberts Drug Store, a mainstay at the northeast corner of Butler Avenue and Main Street from 1894 to 1921, is the picture of neat convenience and old-world charm. Besides the usual pharmaceuticals and related household health aids, the apothecary also offered the locals one of the four soda fountains in town. (Courtesy of Wissahickon Valley Historical Society, 1905.)

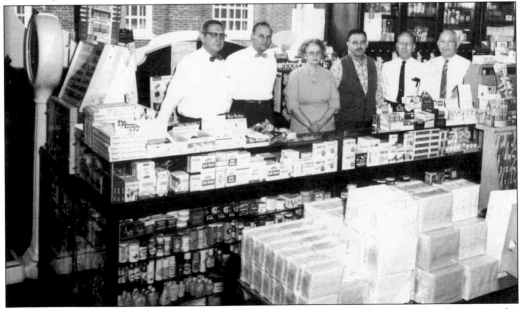

In 1921, Brenneman & Brady's Drug Store replaced the old Rees C. Roberts apothecary at the corner of Butler Avenue and Main Street. Aside from the usual upgrades in products and customer comfort, the store remained basically the same reliable place. Behind the counter is the staff of Brenneman & Brady's. (Courtesy of Wissahickon Valley Historical Society, c. 1960.)

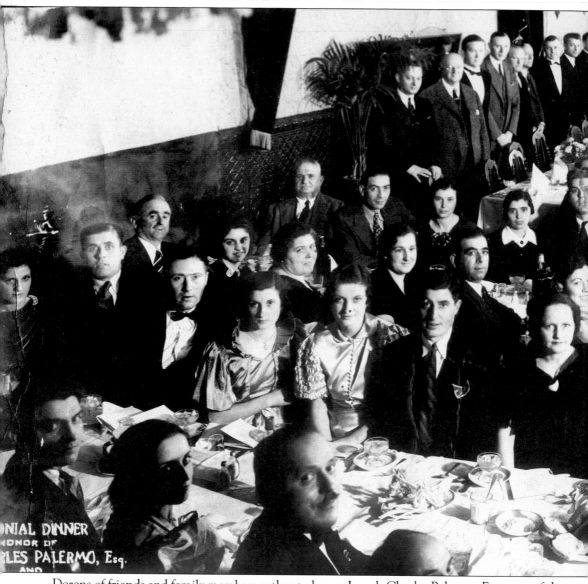

Dozens of friends and family members gather to honor Joseph Charles Palermo, Esq., one of the cofounders of Ambler's Italian-American Citizens' Club LRB Fire No. 43 Home Association, better known as the Sons of Italy, chartered in Ambler on May 8, 1916. Many of these men and women worked for Keasbey & Mattison, still operating at that time. Although many Italians

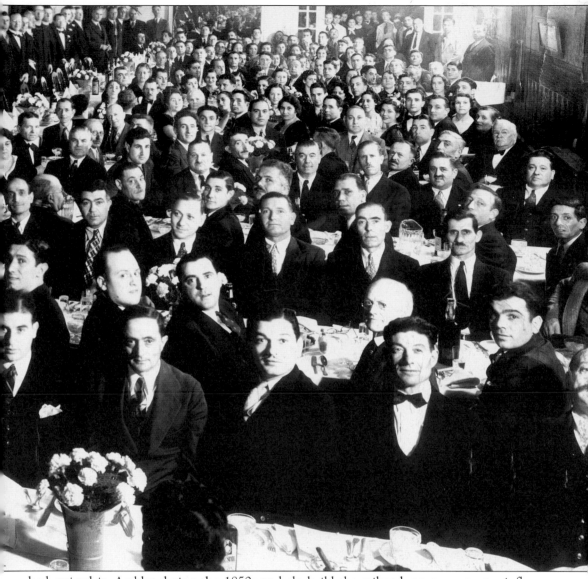

had arrived in Ambler during the 1850s to help build the railroad, an even greater influx, mostly stonemasons, construction workers, and their families, arrived at the beginning of the 20th century to help build Ambler itself. There is still a large and active Italian American community in the borough. (Courtesy of Sons of Italy, November 14, 1937.)

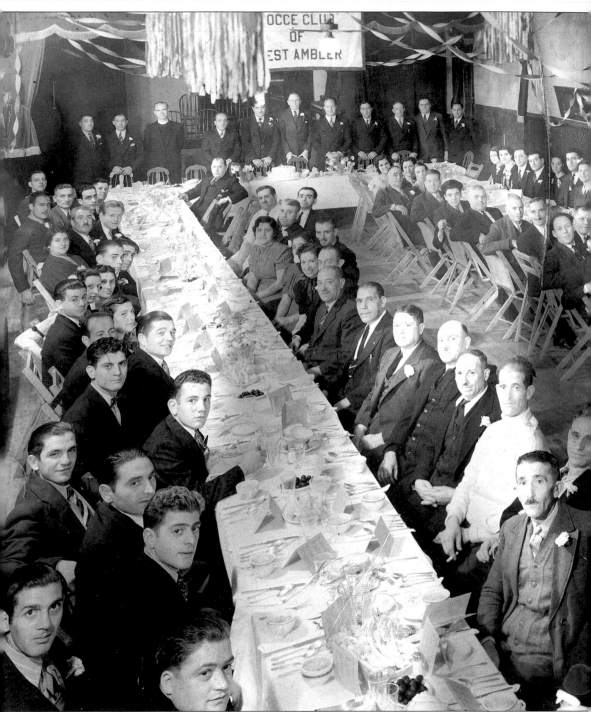

A large contingent of Ambler's Italian American community convenes at the Venetian Club for the fourth annual banquet of the Italian Citizens' Bocce Club of West Ambler. Although the Bocce Club no longer exists, Italian Americans continue to enjoy the comfortable neighborhood feel of Ambler. Author Gay Talese, the son of a tailor who lived in Ambler briefly before moving to Ocean City, New Jersey, visited the borough in 1983 to do some

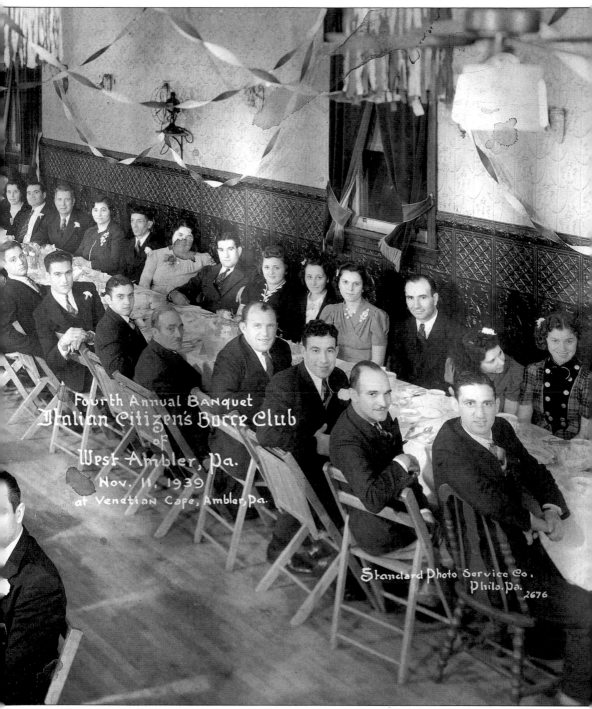

Fourth Annual Banquet
Italian Citizen's Bocce Club
of
West Ambler, Pa.
Nov. 11, 1939
at Venetian Cafe, Ambler, Pa.

Standard Photo Service Co.
Phila. Pa.
2676

research for his book *Unto Thy Sons*. He had discovered during a trip to his grandparents' birthplace, Maida in Calabria, Italy, that his grandparents, like roughly three-quarters of the borough's population, had emigrated to Ambler at the beginning of the 20th century. Italians have long been a major force in Ambler's growth and stability. Ambler's annual St. Francis Day parade honors the patron saint of Maida. (Courtesy of Sons of Italy, November 11, 1939.)

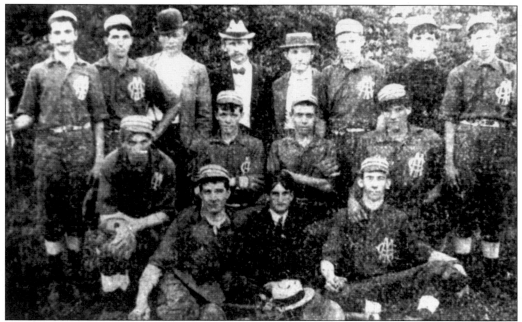

The citizens of Ambler have long enjoyed the camaraderie and good will of several civic and recreational societies, including the Rotary Club, organized and chartered in 1925; the Kiwanis, who came to Ambler under the sponsorship efforts of the Norristown Kiwanis in 1926; the Colony Club, the women's group founded in 1912; the Junior Colony Club, founded in 1921; the antiques aficionados called the Questers (1944); the Ambler Business and Professional Women's Club, chartered in 1945; and others. Shown are the mighty warriors of the Ambler Athletic Club, initiated in 1888 and discontinued in the early 1900s. (Courtesy of Wissahickon Valley Public Library, 1902.)

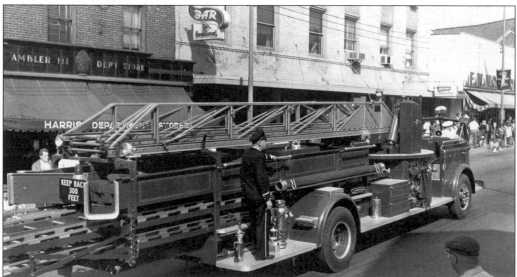

This is a scene from Ambler's Fire Prevention Week parade in 1960. The hardworking volunteer firefighters of the Wissahickon Valley Fire Company responded to 104 calls in 1960, including 32 in Ambler, 27 in nearby Lower Gwynedd, 18 in Whitpain, 12 in Upper Dublin, 5 in Whitemarsh, and 2 in Montgomery. (Courtesy of Wissahickon Valley Fire Company, 1960.)

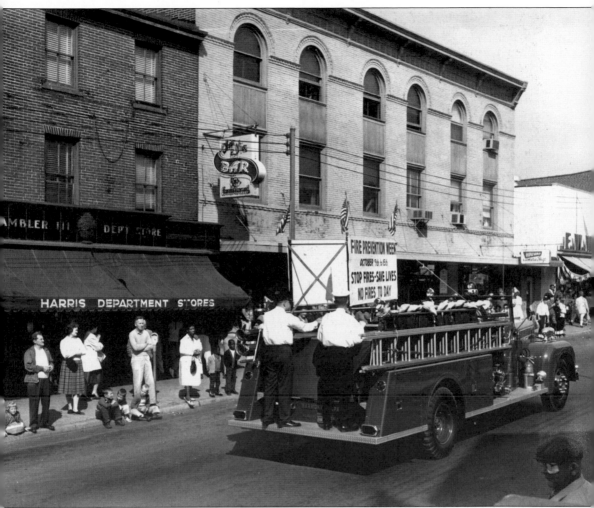

This Fire Prevention Week parade along Butler Avenue was the first one in which the firefighters participated after the Wissahickon Valley Fire Company settled into its new quarters at 245 East Race Street on October 10, 1959. The public joined the firefighters at that time in a celebration featuring a small parade with surrounding fire companies, a friendly competition for trophies, and plenty of refreshments back at the station following the dedication. To the left is the Harris Department Store. In the center is the Ambler Gazette building. To the far right is the F.W. Woolworth store, where downtown Ambler sold things the local folks needed for their daily lives. (Courtesy of Wissahickon Valley Fire Company, 1960.)

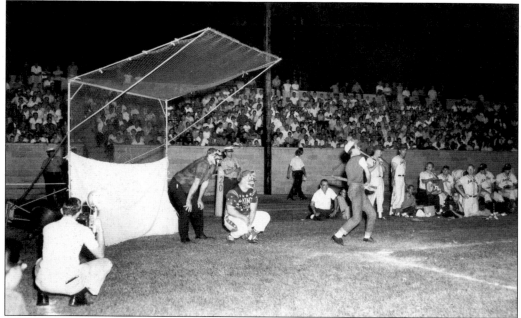

In order to raise enough money to pay off all their obligations before their 75th anniversary in 1965, members of the Wissahickon Valley Fire Company conducted many fund-raisers, among them this exhibition game with the renowned traveling softball team, the King and His Court. The umpire behind home plate (note the telltale extended pinky on his right hand) is former Philadelphia Eagles' Pro Football Hall of Famer Chuck Bednarik, who graciously consented to help the cause just one year after leading the Eagles to the National Football League Championship. (Courtesy of Wissahickon Valley Fire Company, August 1961.)

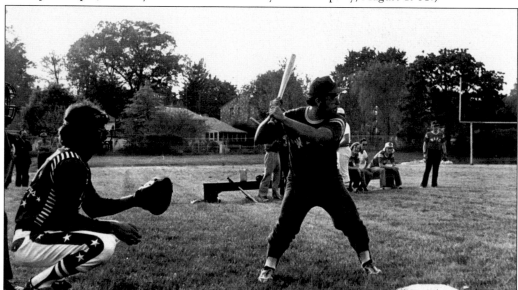

Determination etched on his face, Tom Mastromatto of the Wissahickon Valley Fire Company cocks his bat at the plate, waiting for the next pitch from the King in an exhibition game against the softball touring show, the King and His Court. (Courtesy of Wissahickon Valley Fire Company, 1975.)

118

Eddie Feigner, the longtime leader of the four-man touring softball team the King and His Court, is seen here addressing the fans during an exhibition game against the Wissahickon Valley Fire Company. The King and His Court has played more than 100,000 softball games in 100 countries since incorporating in 1946. Feigner's fast pitch has been clocked at 104 miles per hour. In a two-inning exhibition in 1967, Feigner fanned Willie Mays, Willie McCovey, Brooks Robinson, Maury Wills, Harmon Killebrew, and Roberto Clemente. Now in his 80s, Feigner no longer plays but still fields a four-person team that continues its tours every year. (Courtesy of Wissahickon Valley Fire Company, 1975.)

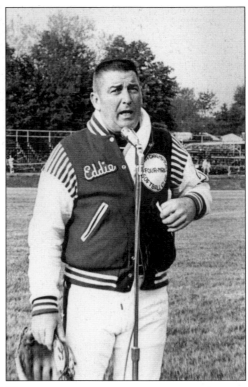

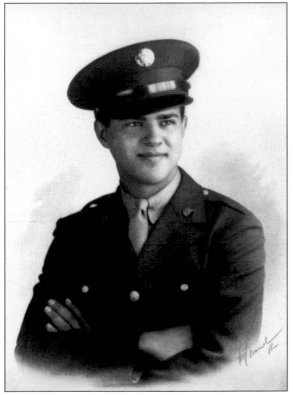

This portrait of Ambler resident Emil Stojanov, taken during World War II, was sent from overseas to the Gerhart family. After the war, Stojanov worked at AMChem, the American Chemical Paint Works, one of Ambler's major industries at the time. Now retired, Stojanov still lives on North Spring Garden Street. (Collection of Ross Gordon Gerhart III.)

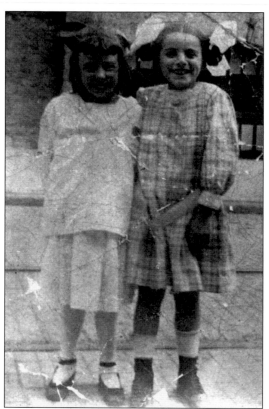

Standing in front of the Wyndham Hotel are Gladys Astor Scheetz (left) and Florence Lapetina. Lapetina's father, Anthony Lapetina, opened Lapetina's Furniture Store, another Ambler landmark, at the beginning of the 20th century. (Collection of Ross Gordon Gerhart III.)

Looking especially peaceful after a February snowfall is a house (upper left) on Ainsworth Street. The house, distinguished by a mansard roof typical of many of the nicer homes in Ambler, was the first residence of Richard V. Mattison when he moved to Ambler in 1882. (Collection of Ross Gordon Gerhart III, 1961.)

These two serious-looking young ladies are Mary Viola Scheetz (left), age three or four, and her sister Elsie Mae Scheetz, age five or six. The younger sister became a secretary at the Boiler Erection Company and later owned and operated the Forrest Knitting Shop. The older one worked as a wrapper in the Keasbey & Mattison magnesium plant and later at her sister's knitting shop. She was good at needlework; she could even tat. (Collection of Ross Gordon Gerhart III.)

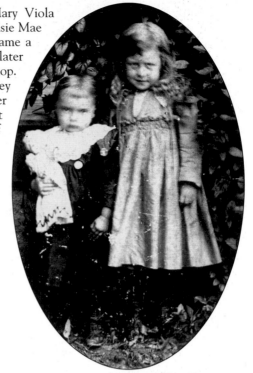

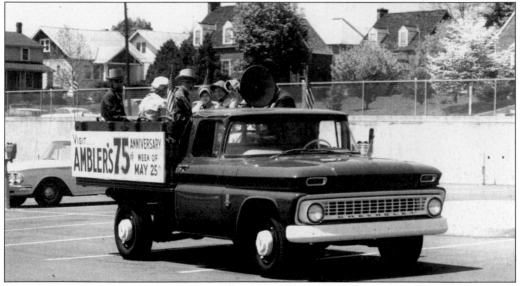

These costumed volunteers sit in the back of the Chevrolet pickup truck in the parking lot on Race Street (the current location of Ambler Savings and Loan). They are announcing the beginning of Greater Ambler's 75th anniversary celebration, held the week of May 25, 1963. The celebration was a lavish community affair, with each day of the week dedicated to a specific theme: Coronation Day (May 25), Faith of Our Fathers Day (May 26), Education Day (May 27), Art Day (May 28), Ladies Day (May 29), Veterans and Youth Day (May 30), Homecoming and Garden Day (May 31), and Parade Day (June 1). (Courtesy of Wissahickon Valley Historical Society, 1963.)

Antique automobiles, as well as beautiful floats and authentic costumes, were part of the festivities during the Grand Float parade on Parade Day, June 1, the final day of Greater Ambler's 75th anniversary celebration. (Courtesy of Wissahickon Valley Historical Society, 1963.)

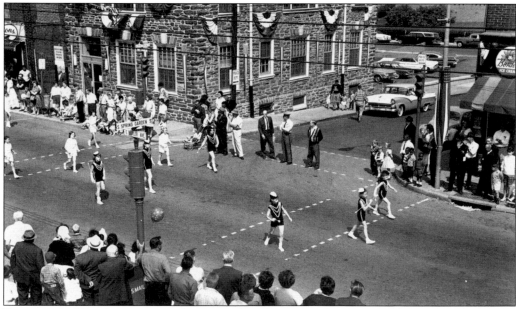

Young and old and everyone in between played a part in Greater Ambler's 75th anniversary celebration during the week of May 25. The parade is passing in front of the Bell Telephone Building at the intersection of Butler Avenue and Spring Garden Street. (Courtesy of Wissahickon Valley Historical Society, 1963.)

122

During the Grand Float parade on Parade Day at Greater Ambler's 75th anniversary celebration, Janet Saul Gerhart in her authentic turn-of-the-century bonnet and dress, sits on one side of a hooded cradle. Sitting on the other side of the cradle is her three-year-old son, Ross Gordon Gerhart III. In the Hitchcock chair is the boy's grandfather Ross Gordon Gerhart Sr. Driving the 1922 Ford Model TT truck is the boy's father, Ross Gordon Gerhart II, owner of Gerhart's Antiques, a mainstay in Ambler since its founding in the 1930s. (Photograph by Newton Myers Howard, collection of Ross Gordon Gerhart III, 1963.)

Posing are some select Brothers of the Brush, Wissahickon Valley Fire Company members who decided to let their hair down, or at least let their beards grow long, in honor of Greater Ambler's 75th anniversary. Because of such good-natured antics, for part of the year, the borough of Ambler appeared to have been caught in an amusing time warp. (Courtesy of Wissahickon Valley Fire Company, 1963.)

The Ambler Police Department also got into the act during the 75th anniversary proceedings. Doing their best to emulate the Keystone Kops are the "convict," gamely played by officer Walt Dots, and his arresting officer, played by Don Cassel in a real stretch from his full-time occupation. (Courtesy of Wissahickon Valley Historical Society, 1963.)

In this photograph of mock futility, three residents of Ambler, all decked out in turn-of-the-century garb, try vainly to fit a 19th-century coin into a 1963 parking meter—all part of the fun during the Greater Ambler 75th anniversary celebration. They might even have been among the participants in Frontiers of Freedom, a gigantic historical spectacular that was staged on the Ambler Junior High School field from May 27 through June 1 of that memorable week. (Courtesy of Wissahickon Valley Historical Society, 1963.)

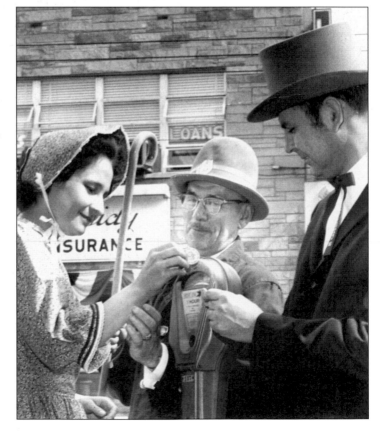

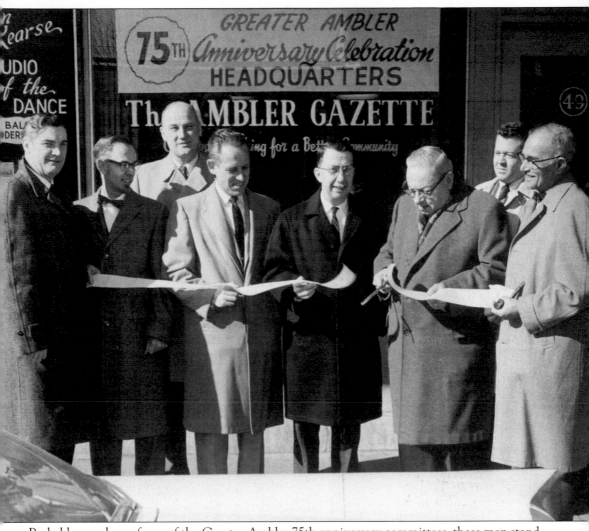

Probably members of one of the Greater Ambler 75th anniversary committees, these men stand in front of the *Ambler Gazette*, the borough's award-winning weekly newspaper. The *Gazette* came into being in 1882, six years before the borough was incorporated, when Horace G. Lukens and his staff began reporting all the news that was fit to print about this growing community. Since Henry G. Keasbey and Richard V. Mattison had transplanted their pharmaceutical company from Philadelphia to Ambler in 1881, industry was picking up. Jobs were here for the taking, the economy was steadily spiraling upward, and a healthy spirit of optimism pervaded the community. The *Gazette*, now located at the headquarters of Montgomery Newspapers in Fort Washington, has been a major force in Ambler for well over 100 years. (Courtesy of Wissahickon Valley Historical Society.)

No one can accuse the citizens of Ambler of being shy when any cause for celebration arises. Here, they gather across from the old post office building during the Christmas season to welcome Santa to the community for his annual visit. They are standing by an igloo built from blocks of ice and snow for Santa. These days, Santa arrives by train at Ambler Station and then proceeds down Butler Avenue in a parade that brings out the holiday spirit in all Amblerites. (Courtesy of Wissahickon Valley Historical Society, 1963.)

Sitting on the front step of their home on Chestnut Street in South Ambler are Mable May (Jones) Smith and her son Russell Smith. (Collection of Ross Gordon Gerhart III.)

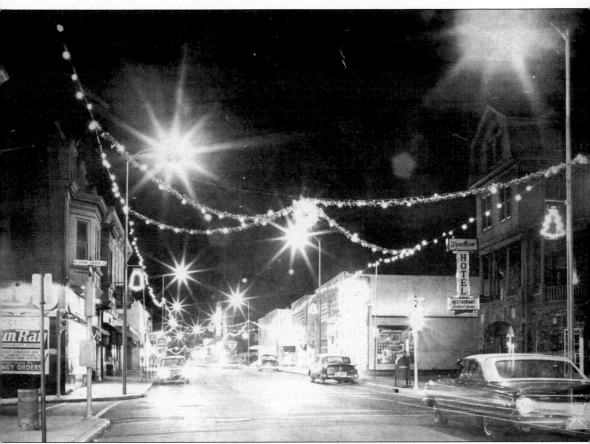

Butler Avenue at Spring Garden Street seems to shine with holiday spirit. Notice the Sun Ray drugstore on the corner, now the home of Fine Things. For years Richard V. Mattison used to arrange for the decoration of the big spruce tree next to the Wyndham Hotel. Using tall fire engine ladders from the Wissahickon Valley Fire Company, volunteers would trim the great Christmas tree from the top on down, and all of Butler Avenue and the citizens of Ambler would shine with the spirit of the season. (Courtesy of Wissahickon Valley Historical Society.)

ACKNOWLEDGMENTS

This pictorial history of Ambler would not have been possible without the invaluable assistance of the Wissahickon Valley Historical Society and its knowledgeable president, historian Frank Russo Jr., who provided me with countless leads, photographs, anecdotes, and complete access to the society's extensive collection. When he was unable to join me at the society's historic headquarters, at the charming site of an elementary school built in 1895, good-humored librarian Bob Virkler served as a suitable and well-informed surrogate.

Ambler's longtime Main Street manager Bernadette Dougherty, who has amassed as much information on the community's long life as any formal historian, offered several leads and contacts, and much moral support.

Other photographs and assistance came from the archives of some wonderfully generous Amblerites, including Anthony Minio, the hearty fire chief of the Wissahickon Fire Company, and faithful firefighters Buck Amey (another local historian) and Vince Votta; Ambler borough Councilman (and Sons of Italy members) Sal Pasceri and his wife, Dolores; Wissahickon Valley Public Library director David Roberts and branch librarian Lois McMullen; Trinity Memorial Episcopal Church administrator John Dziel; Ambler Church of the Brethren administrative assistant Lori Hill; and especially Ross Gordon Gerhart III, whose exceptional collection of photographs (and hospitality) added immeasurably to the face of Ambler depicted in this book. Thanks also to the hospitality of Gordon's wife, Elaine, and his parents, Ross G. and Janet Gerhart Jr., whose interest in this project is very keen.

I also wish to acknowledge the expert photograph-scanning advice of Glenn Miller, the reassuring legal counsel of friend and fellow author Richard Bank, the recording wizardry of Jennifer Casey, the sure packing hand of Pat Burke, the layout and design skills and emotional boost provided by good friend Alexandra Lindquist, who ventured down from upstate New York to help me during the final days, and many, many others (including my patient and understanding students) whose general moral support proved even more of the foundation I needed to complete this book.

I offer my sincere gratitude to my first editor at Arcadia, Jennifer Villeneuve, who helped me launch this project, and especially warm thanks to Erin Loftus, my current editor at Arcadia, whose cheerful professionalism and resourcefulness never failed to buoy me up during those final weeks.